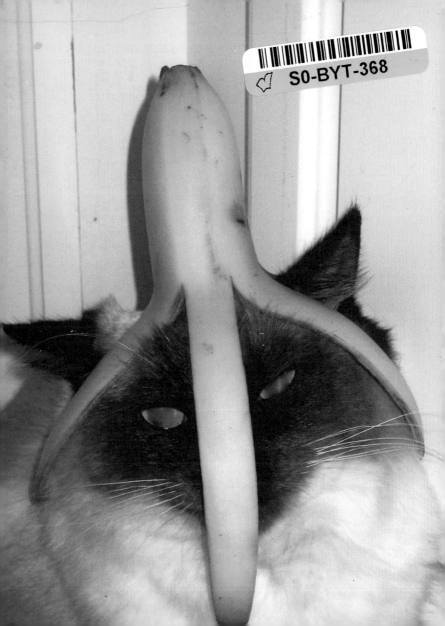

MORE

stuff on my

CHRONICLE BOOKS
SAN FRANCISCO

2x the stuff + 2x the cats = **4x the awesome**

cat

By Mario Garza

Copyright © 2008 Mario Garza

Library of Congress Cataloging-in-Publication Data available.

ISBN: 978-0-8118-6225-7

Manufactured in China

Design by Viola E. Sutanto

Drawings by Dath P. Sun

10 9 8 7 6 5 4 3 2 1

Chronicle Books LLC
680 Second Street
San Francisco, California 94107
www.chroniclebooks.com

INTRODUCTION

My cat, Love, has just woken up from a nap. She greets me at my office door with a halfhearted meow, plops down next to my chair, and demands to be petted. I give her a healthy scratch behind the ears and return to updating my Web site, the one that she unknowingly inspired and that has attracted millions of visitors and spawned a cultlike following among some viewers: Stuffonmycat.com.

I've been putting stuff on my cat for as long as I can remember; one day in 2005, I thought it would be fun to start a site dedicated to the activity. I launched Stuffonmycat.com with a few photos of stuff on Love and asked others to get in on

5

2x the stuff + 2x the cats = **4x the awesome**

the action and submit their own photos. Boy, did they! Within a few months, the site was a smash hit. To date, I've received over 60 million visitors and 25,000 photos from all over the world. Far from just being a place where one can see funny photos of cats, Stuff on My Cat has fostered a diverse and healthy online community. To some, it's not just another Web site—it's a hobby, an obsession, or a showcase for works of art. I've received a lot of fan art over the past couple of years, from watercolor paintings to poems to crayon drawings to a miniature Stuff on My Cat statue that resides on my desk. There's a Stuff on My Cat Social Club, which consists of college students who party on weekends in their Stuff on My Cat shirts. Just recently the site facilitated an online marriage proposal— someone popped the big question to his long-term girlfriend by way of an engagement ring on top of their cat. (She said yes.)

With the site's success, there are a few cats who have become mini-celebrities. Q the cat was on the cover of the first *Stuff on My Cat* book; he's best known for his unique eye colors. Tom is a gray kitty who will dress up in anything and everything imaginable. (He has his own series in this very book!) Luke is known for having some of the funniest and most creative stacks the site has ever seen. He has dressed up as a bug

exterminator, a pirate, and a gym member, and has even reenacted a scene from *Titanic*. It's strange—I've never met these cats and probably never will, but I feel like I know them. If I ever saw one of them resting on a windowsill I would recognize him or her immediately . . . and immediately commence an obligatory stack.

Meanwhile, my cat, Love, hasn't let the fame go to her head. At the ripe age of fourteen, she enjoys spending her days doing what she does best: lounging. She seems to be a little more wary of my antics, though. She's caught on to this putting-stuff-on-her-and-snapping-a-picture game, and has become picky about where she takes naps.

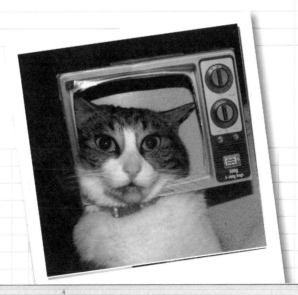

I'm not certain, but I think she sleeps in spots with minimal stacking potential—such as in a corner rather than out in the open, so that I can't catch her unaware. Now, whenever she wakes up and realizes she's been stacked, she hunts me down and gives me that "you got me" glare. Sometimes she stops me in the middle of a stack, too. I know I've been caught when I hear her prehistoric-dinosaur meow beneath her breath. She'll get up (slowly), knocking off whatever nonsense I tried to put on her this time. She'll have a look of defeat on her face, ashamed that she let her guard down even for a second. Not to worry, though; things are always settled with a tummy rub and comb-down.

I'm often asked, "Why is putting stuff on your cat so funny?" No matter how much I think about it, I can't formulate the words that explain it perfectly. It's cute, unique, and incredibly random. I think the cat's face has a lot to do with the appeal. You can practically see her wondering, "What has suddenly possessed my human to dress me up as a bumblebee?" or "What the heck is that and why is it on my head?" Explainable or not, I'm glad I found other people who enjoy stuff-on-cat action as much as I do. Alone, we're weird people who have a fondness for an odd but surprisingly entertaining activity with

our cats. But *together* we're a group of weird individuals who are fond of this strange activity with our cats, which is somehow validating. You too can join us and be a part of this madness! We would love to have you. Who knows—your cat might end up becoming the next Stuff on My Cat celebrity. Happy stacking!

—Mario Garza

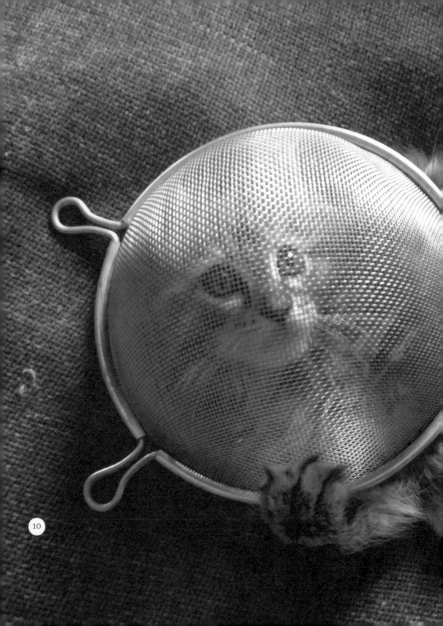

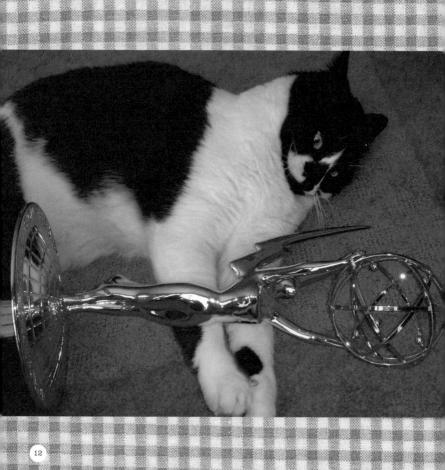

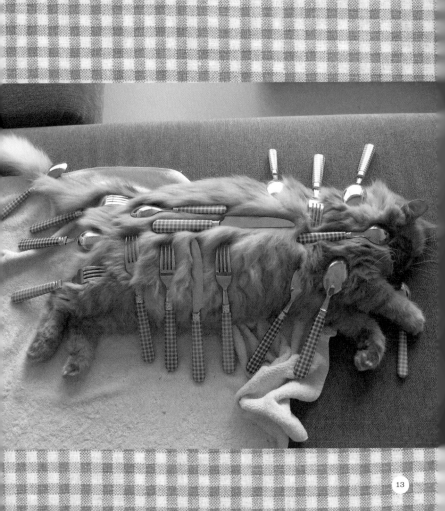

One of Amber's favorite things to do in life is to "help" Mama and Daddy with the laundry. At first she's just happy to lie there content in the warmth. But then she realizes something: The pile is growing smaller!

It is a fight to the death for the remaining clothes. We have to sneak pieces away while she's not looking. And if your hand gets too close, you're gonna get nipped! Sometimes, just to get the rest folded, we have to "sacrifice" a piece of clothing to her.

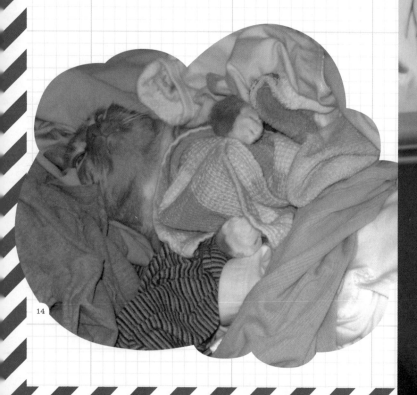

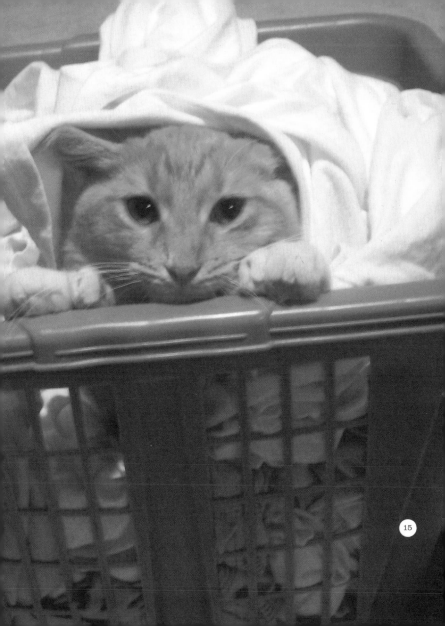

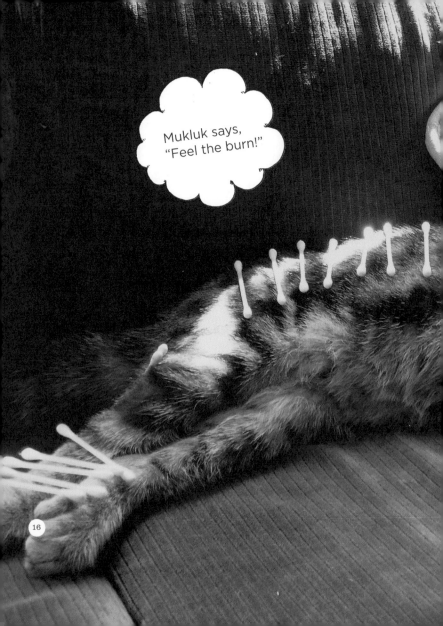

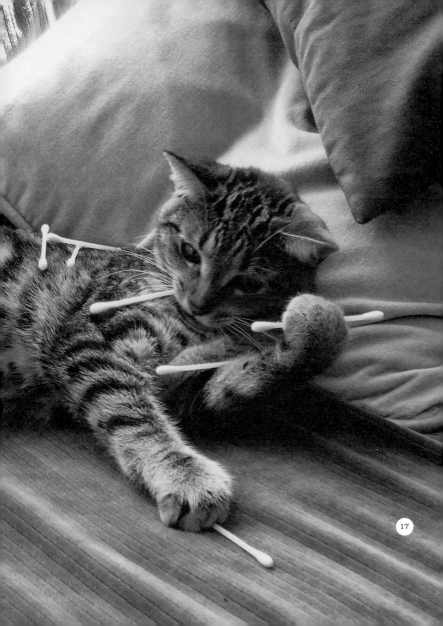

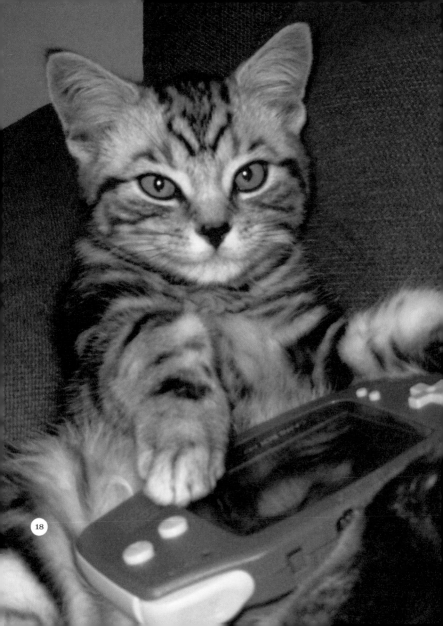

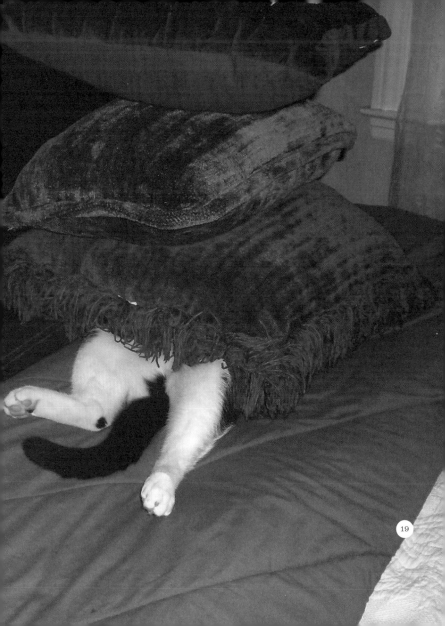

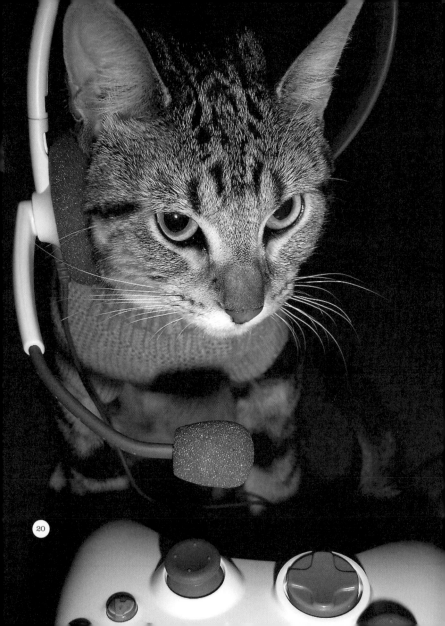

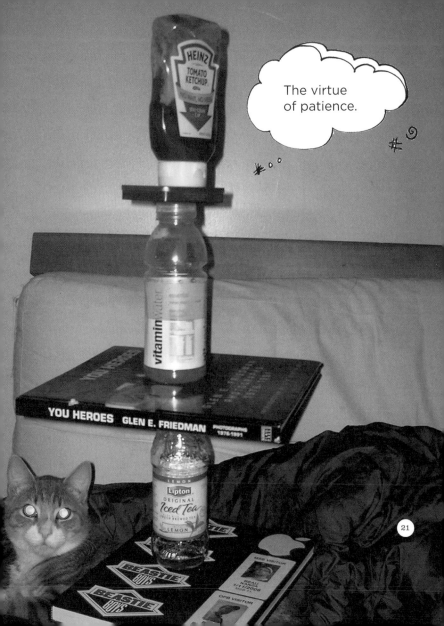

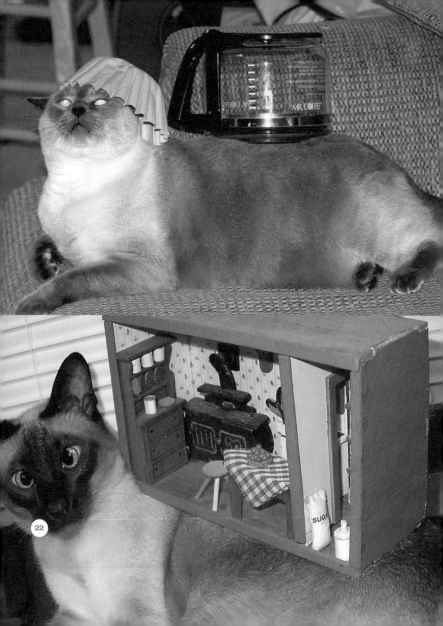

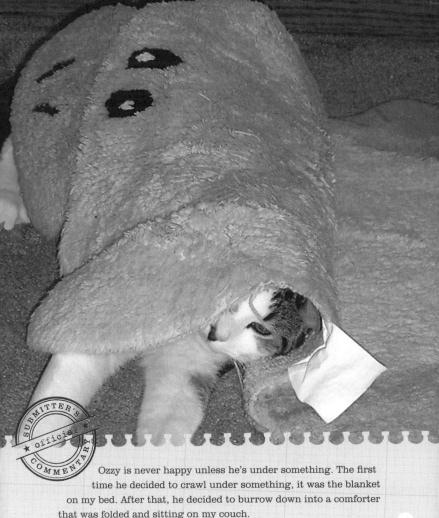

Ozzy is never happy unless he's under something. The first time he decided to crawl under something, it was the blanket on my bed. After that, he decided to burrow down into a comforter that was folded and sitting on my couch.

23

One day I was stepping out of my shower onto my bathroom rug, which is shaped like a duck, when I noticed there was something moving under it. Since then, Ozzy has battled the rug on several occasions and never quite seems to be able to win.

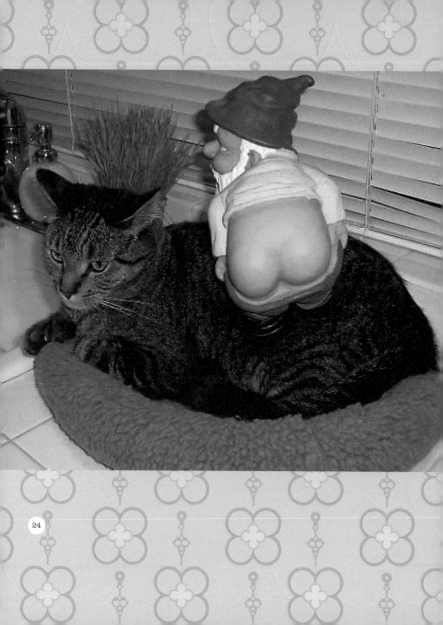

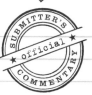
Javi got into this sticky situation when I had guests coming over to my house for the first time and I was furiously attempting to "de–cat hair" the futon. I was using the duct-tape loops to pick up the cat hair on the blanket, painstakingly covering every inch in a methodical pattern. Javi would wait patiently until my work was completed on a section, and then he would promptly move to the newly clean spot and rub and roll as much as he could. Once he'd completed his own "work" on the section, he would look at me proudly, as if he expected me to reward him with a treat for doing such a great job on stalling my progress. This process of de–cat hairing and re–cat hairing took the greater part of a Saturday afternoon.

27

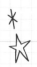

30

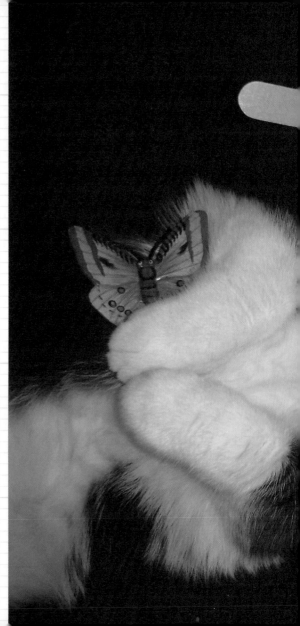

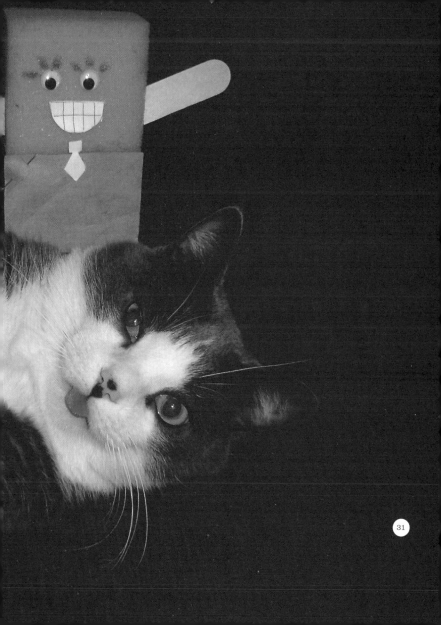

ZZZZZ

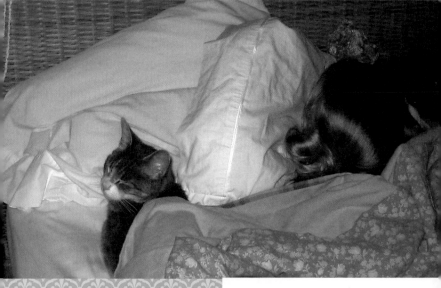

I've learned to deal with the bed-hogging, and now I sleep very still. Babydoll has clawed me a couple times for fidgeting; apparently she doesn't like her beauty rest disturbed.

SUBMITTER'S official COMMENTARY

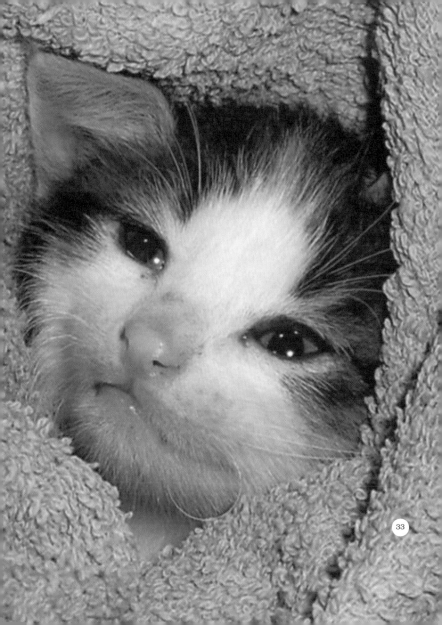

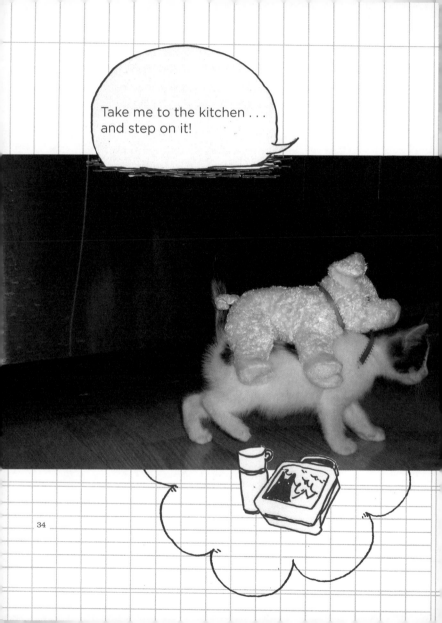

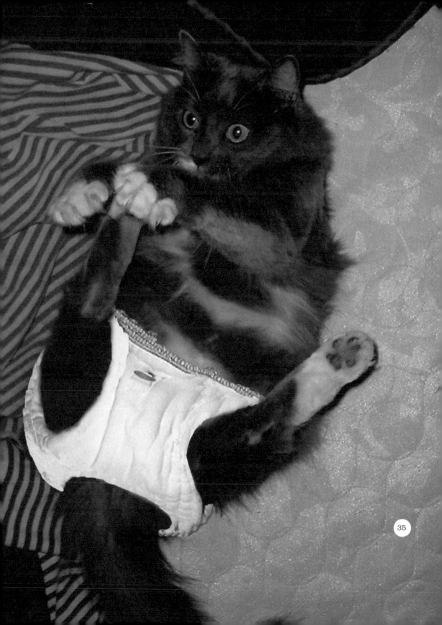

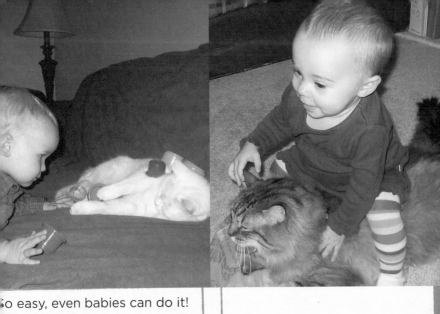

So easy, even babies can do it!

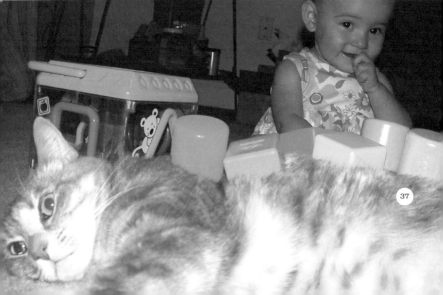

37

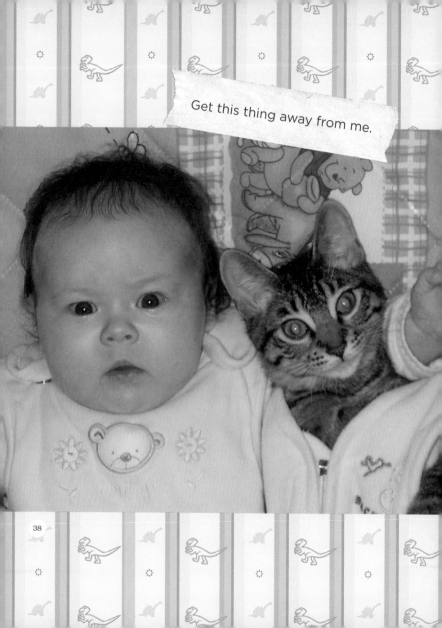

Get this thing away from me.

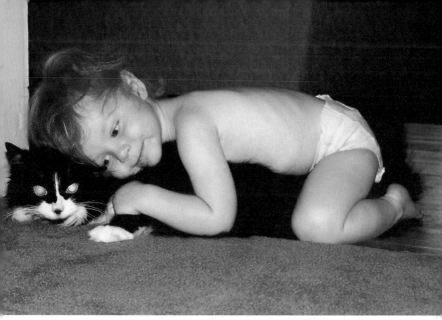

I think we have different ideas of what a "play date" is.

I spy a five, **5** a little airpl

a soccer ball.

a soccer ball.

See the pictures! Hear the chee

These little books are just for you

Books in the I Spy Little Bool

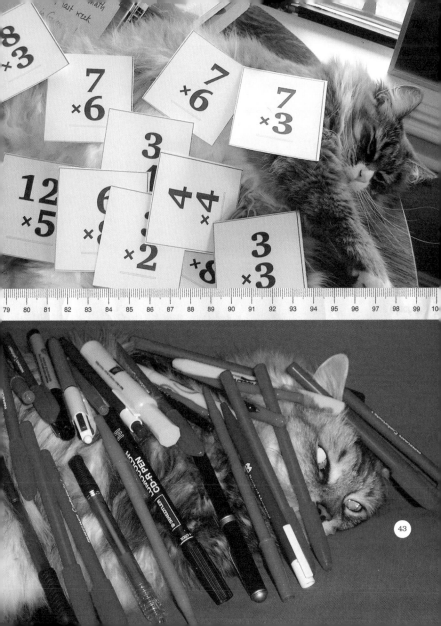

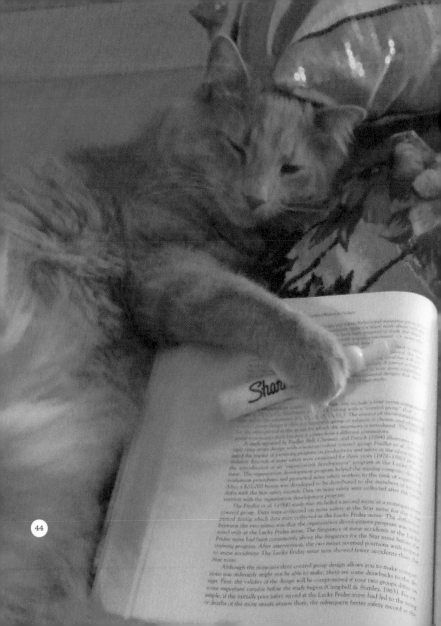

A study reported in Fiedler, Bell, Chemers, and Patrick (1984) illustrates a topic time-series design using a nonequivalent control group. Fiedler et al. studied the impact of a training program on productivity and safety in the silver mines. Reductions in mine safety were examined for three years (1978–1982) preceding the introduction of an "organization development" program at the Lucky Friday mine. The organization development program helped the mining company develop evaluation procedures and promoted mine safety to workers to the risk of accidents. Also, a $35,000 bonus was developed to be distributed to the members of mine safety... Data on mine safety were collected after the intervention with the organization development program.

The Fiedler et al. (1984) study also included a second mine at a nonequivalent control group. Data were collected on mine safety at the Star mine for the same period of testing which data were collected at the Lucky Friday mine. The data collected only at the Lucky Friday mine. The frequency of mine accidents at the Lucky Friday mine had been consistently above the frequency for the Star mine before the training program. After intervention, the two mines reversed positions with respect to mine accidents. The Lucky Friday mine now showed fewer accidents than the Star mine.

Although the nonequivalent control group design allows you to make comparisons you obviously might not be able to make, there are some drawbacks to the design. First, the validity of the design will be compromised if your two groups differ in some important variable before the study begins (Campbell & Stanley, 1963). For example, if the initially poor safety record at the Lucky Friday mine had led to the firing or deaths of the mine unsafe miners there, the subsequent better safety record at the...

Bailey was supposed to be studying for his big Research Methods mid-term. But around 4 A.M., he had just had **enough!**

45

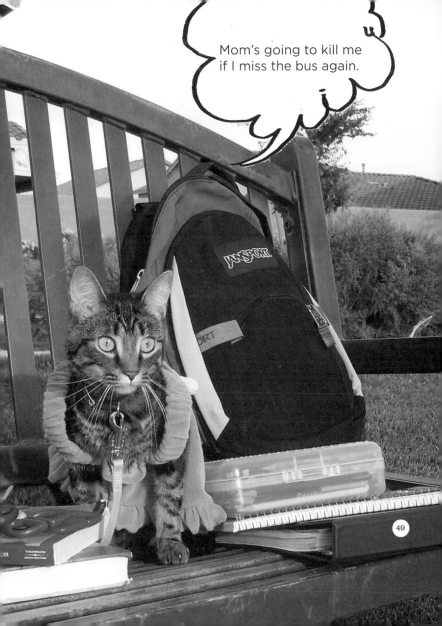

Go on without me!

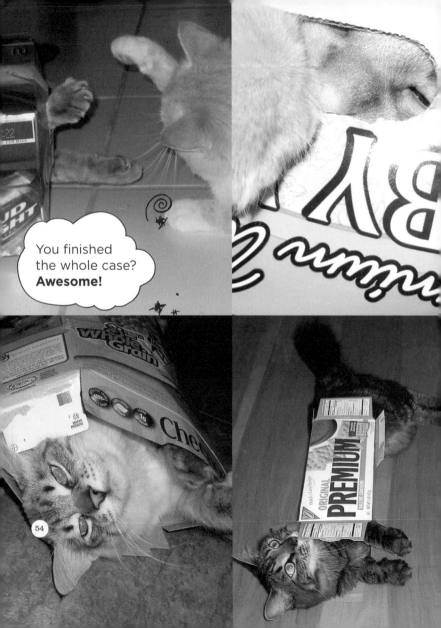

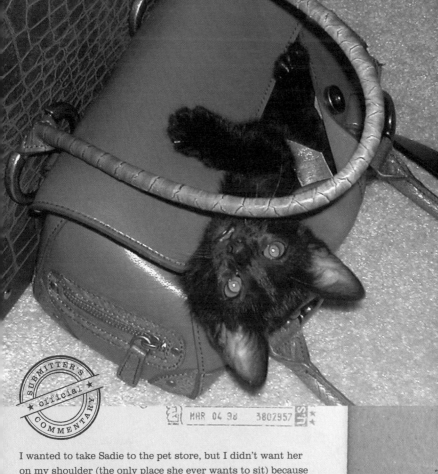

MAR 04 98 3802957

I wanted to take Sadie to the pet store, but I didn't want her
on my shoulder (the only place she ever wants to sit) because
she sometimes scratches me, so I took my wallet out of my
purse and put the kitty in. She loved it. She kept looking out,
then getting back in where no one could see her. When I got
home, I took her out of my purse, and she jumped straight back
in, and played in it for about thirty more minutes.

55

first class

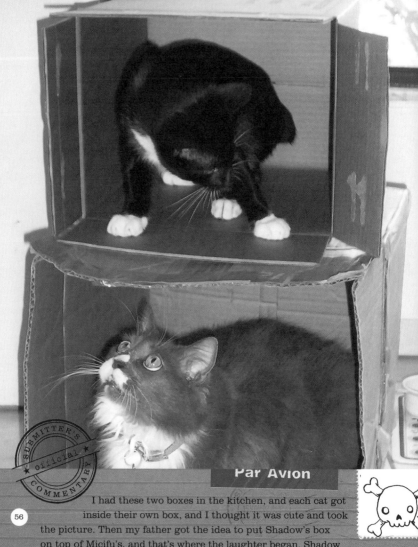

I had these two boxes in the kitchen, and each cat got inside their own box, and I thought it was cute and took the picture. Then my father got the idea to put Shadow's box on top of Micifu's, and that's where the laughter began. Shadow had been in the back of the box, and when he noticed that Micifu was below him, he walked to the edge of the box, which was just the flap, and his box collapsed and he fell on top of Micifu.

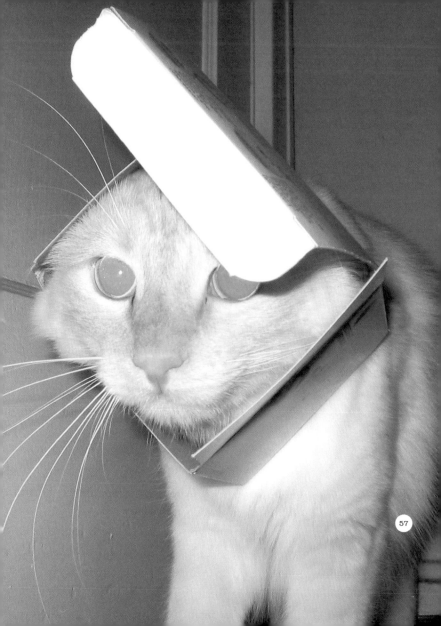

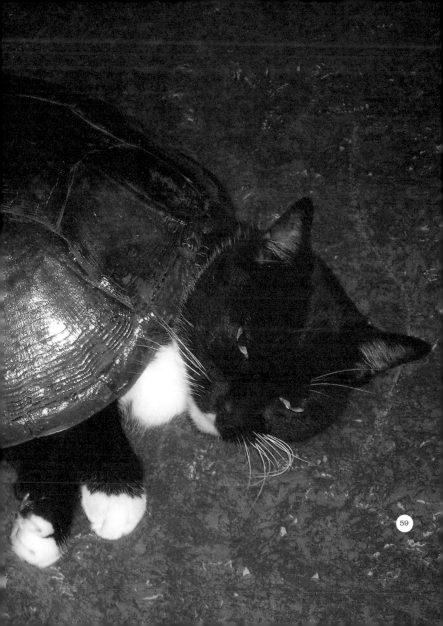

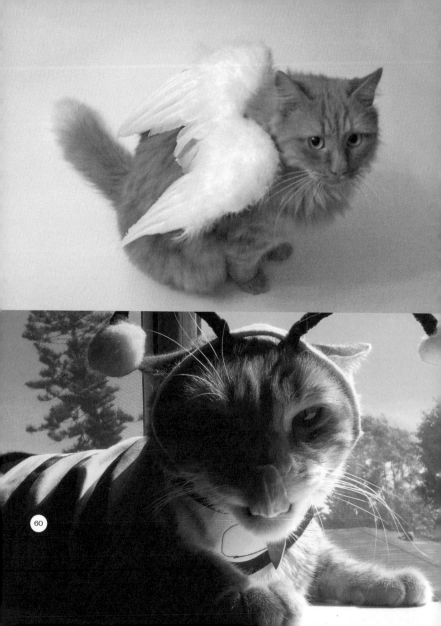

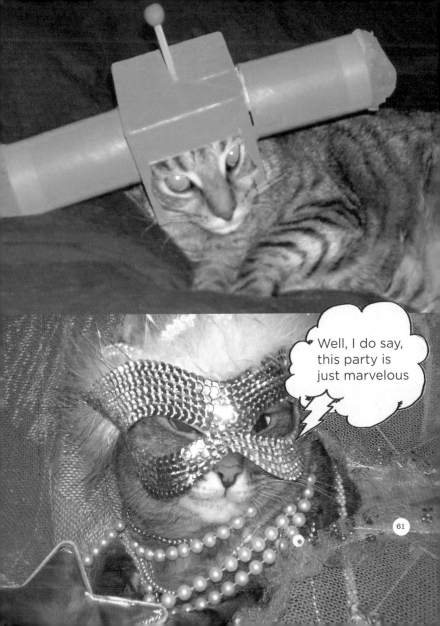

61

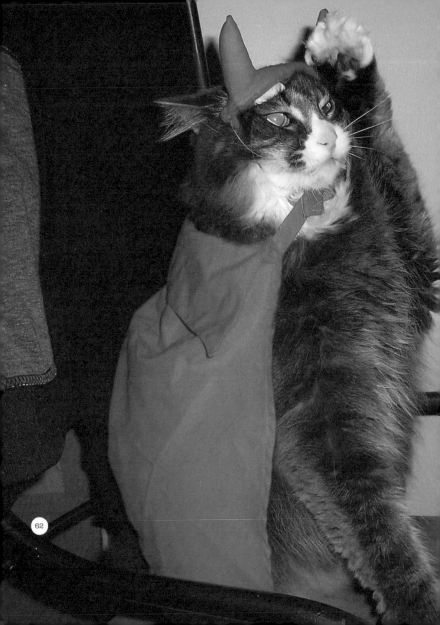

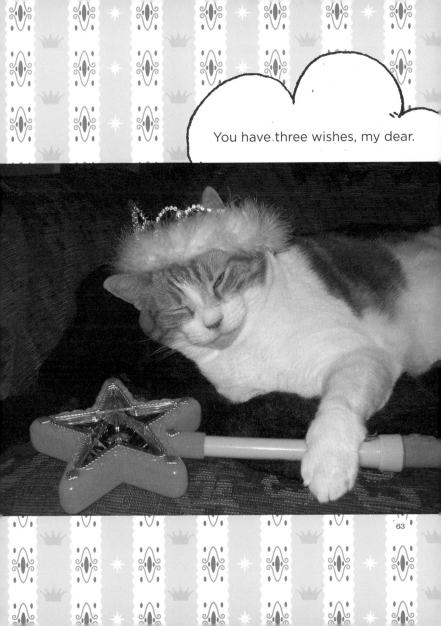

You have three wishes, my dear.

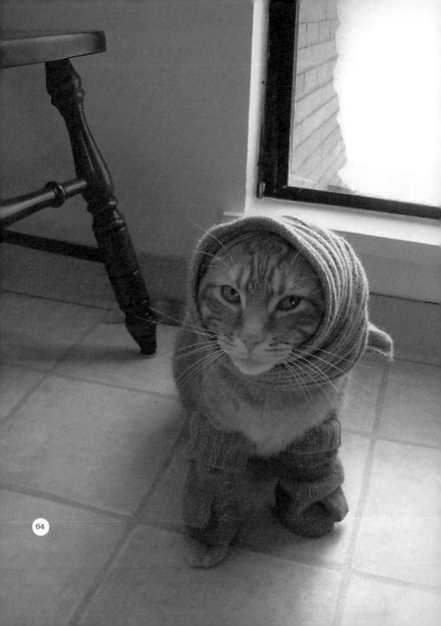

Sailor was raised in a sorority house with thirteen girls, so as you can guess, he is a ladies' man. The only thing it takes for me to get Sailor to pose in an outfit is to have some treats on hand. He has a lot of boundless energy, which he likes to use by bouncing off of walls or seeing how high he can jump in door frames.

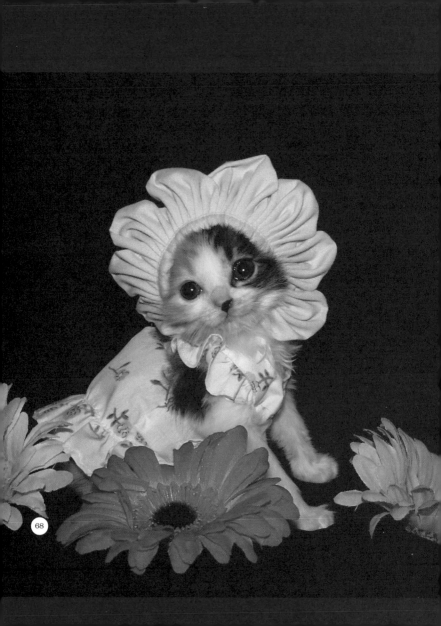

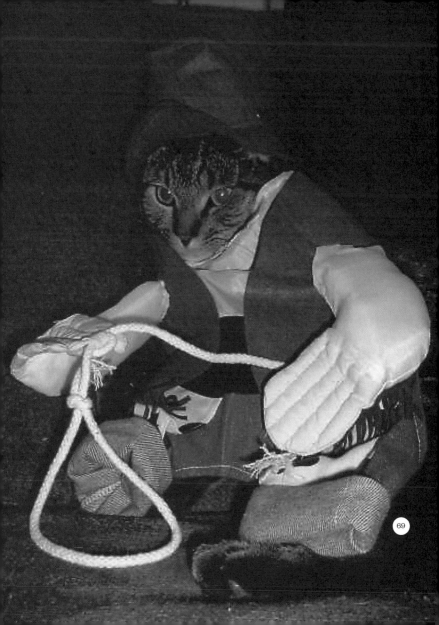

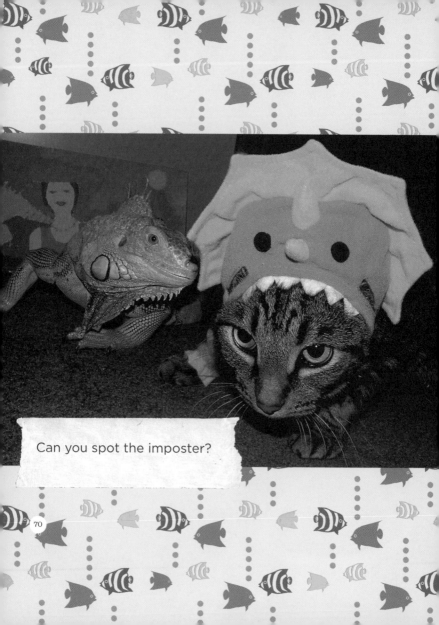

Can you spot the imposter?

70

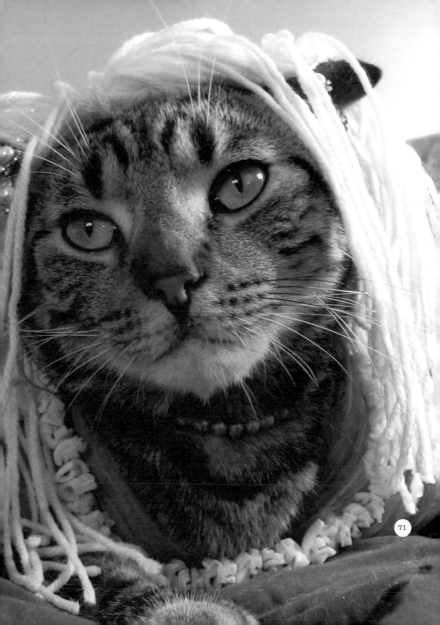

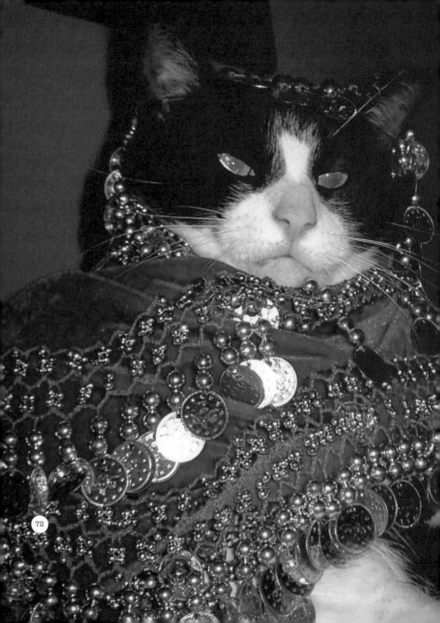

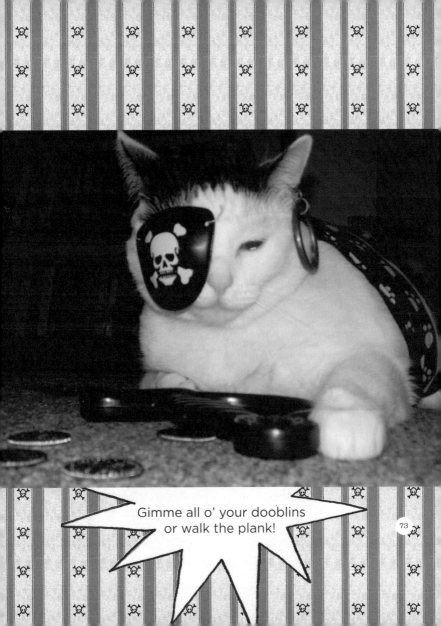

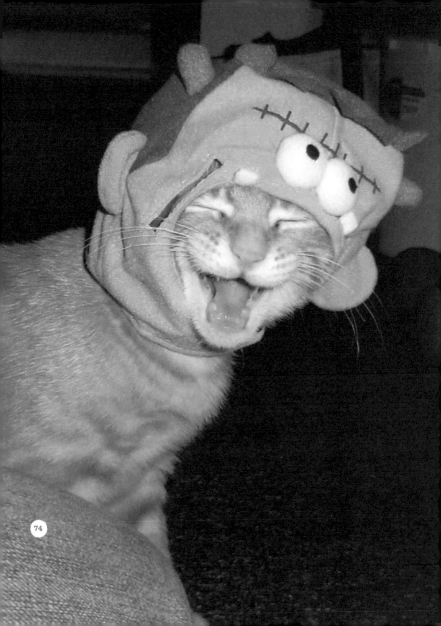

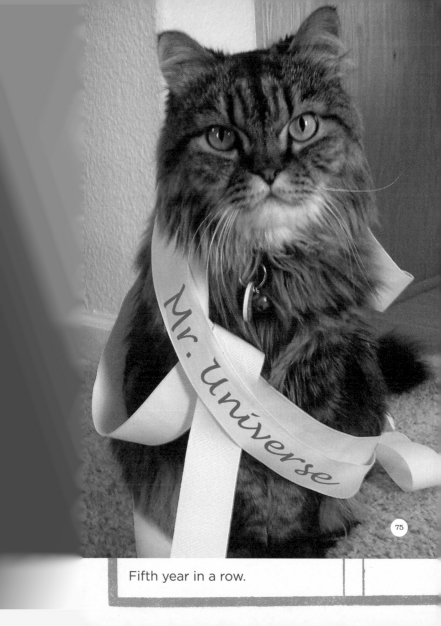

Fifth year in a row.

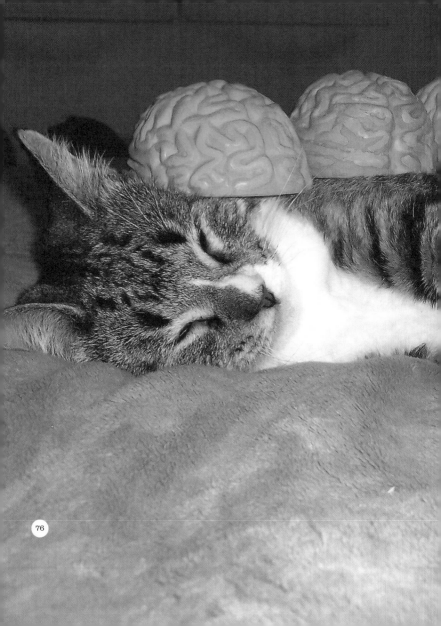

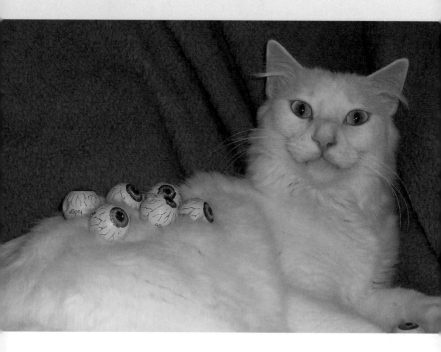

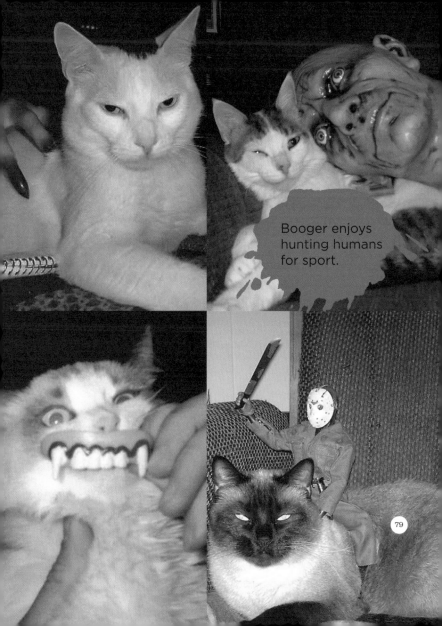

Booger enjoys hunting humans for sport.

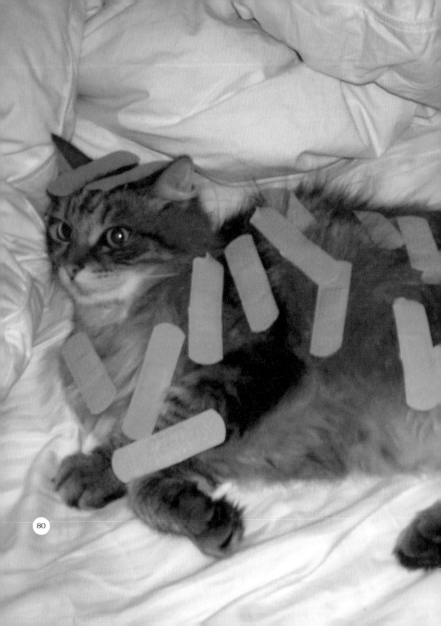

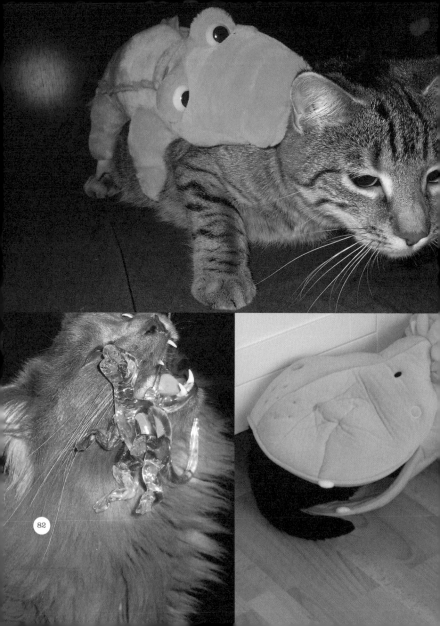

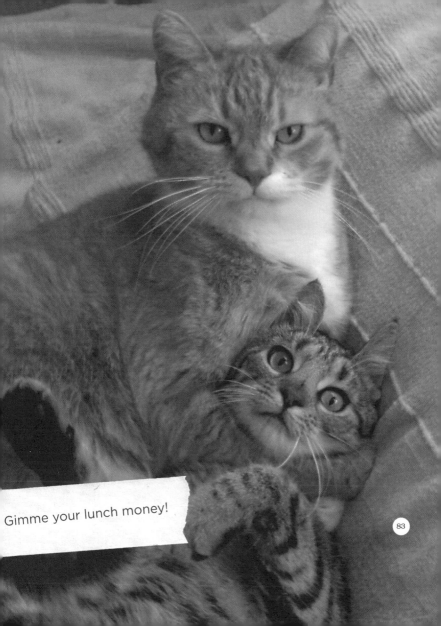

Gimme your lunch money!

Norman's favorite games include:

"Follow That Human!"
RULES: Can be played at any time, but must be played if it is dinnertime and your wet food has not been presented to you in a timely manner.

"Gaze in Awe and Wonder!"
RULES: It's most fun while your human performs odd grooming rituals, like brushing teeth and bathing in water.

"Run from Room to Room for No Reason!"
RULES: This game has no rules; however, it should be played as loudly as possible—really try to make it sound like a herd of elephants has moved in. Crashing into things is optional for added enjoyment.

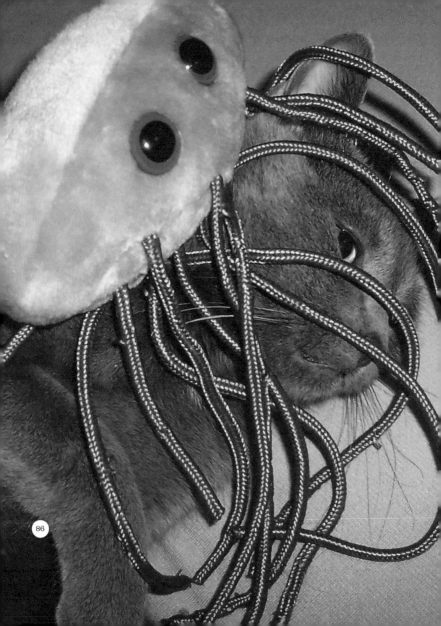

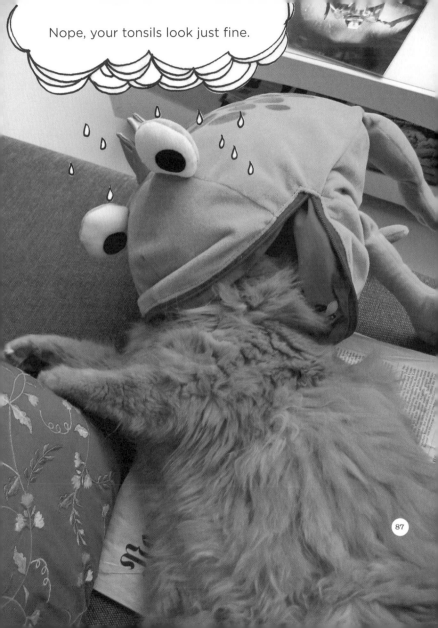

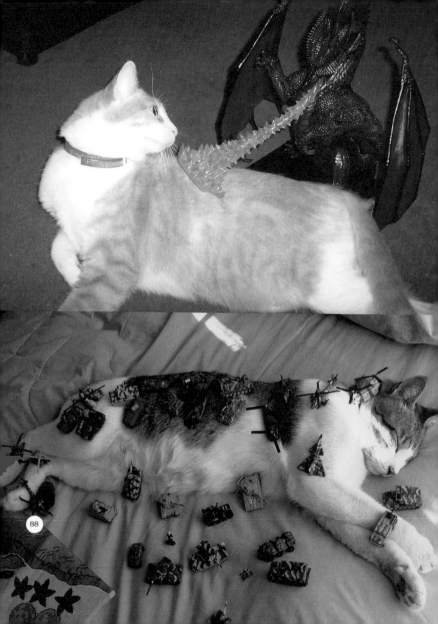

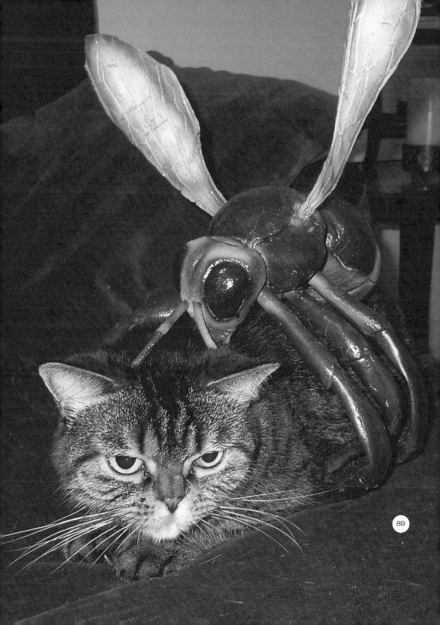

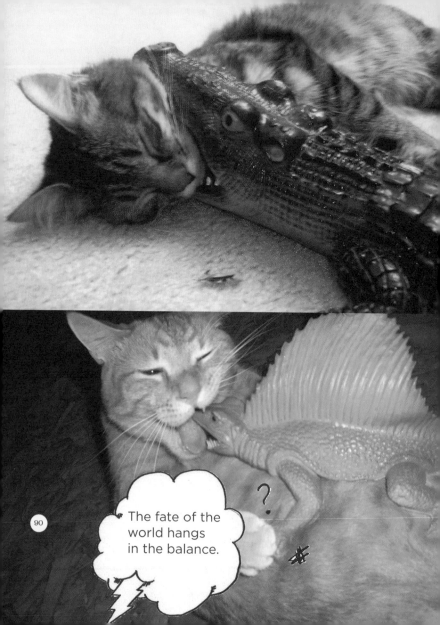

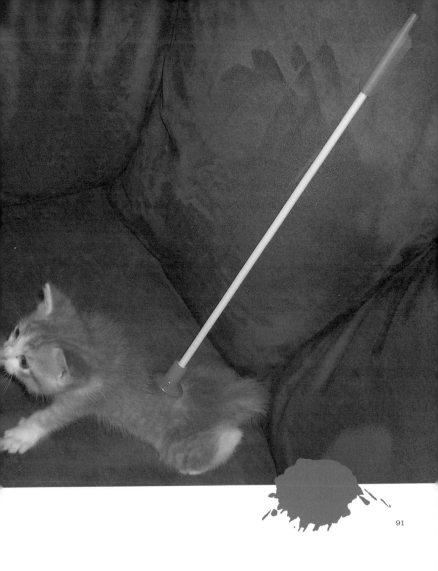

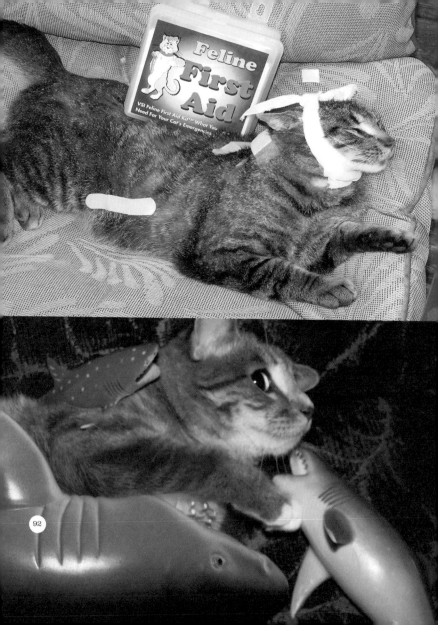

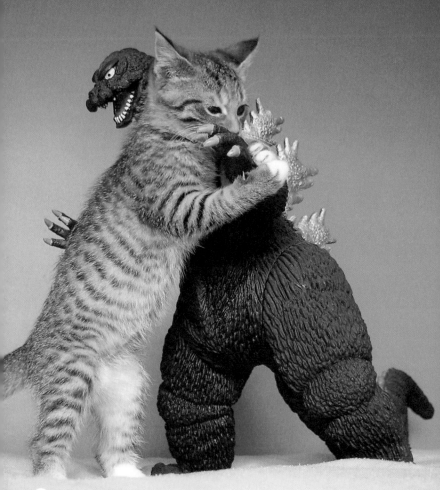

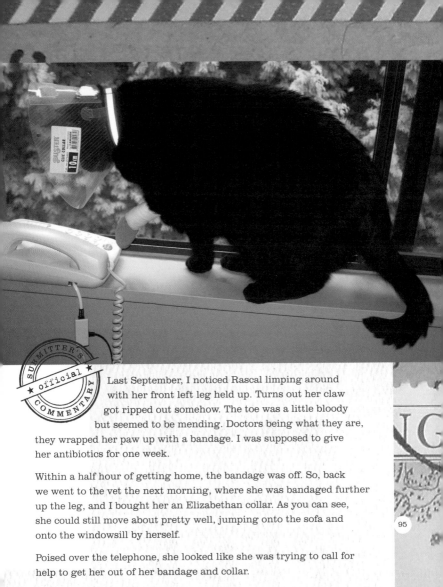

Last September, I noticed Rascal limping around with her front left leg held up. Turns out her claw got ripped out somehow. The toe was a little bloody but seemed to be mending. Doctors being what they are, they wrapped her paw up with a bandage. I was supposed to give her antibiotics for one week.

Within a half hour of getting home, the bandage was off. So, back we went to the vet the next morning, where she was bandaged further up the leg, and I bought her an Elizabethan collar. As you can see, she could still move about pretty well, jumping onto the sofa and onto the windowsill by herself.

Poised over the telephone, she looked like she was trying to call for help to get her out of her bandage and collar.

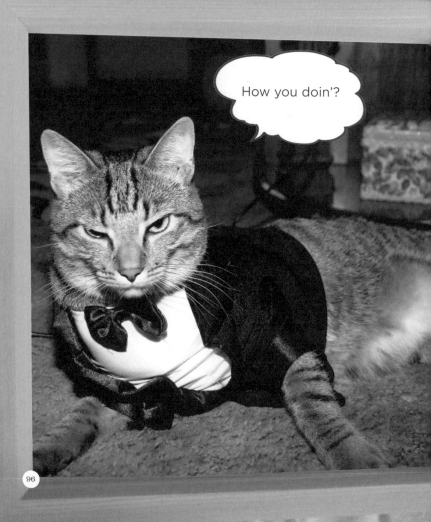

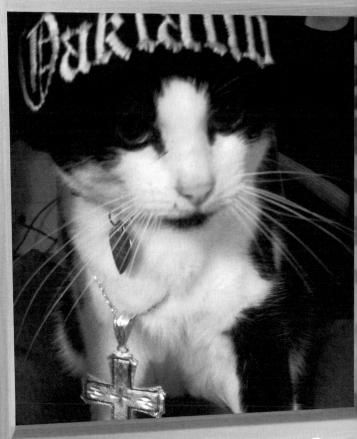

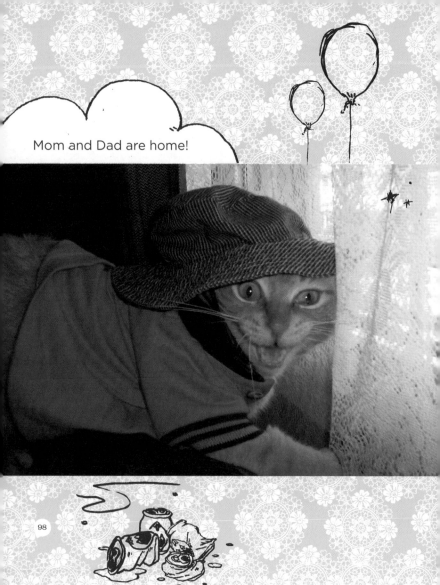

Mom and Dad are home!

98

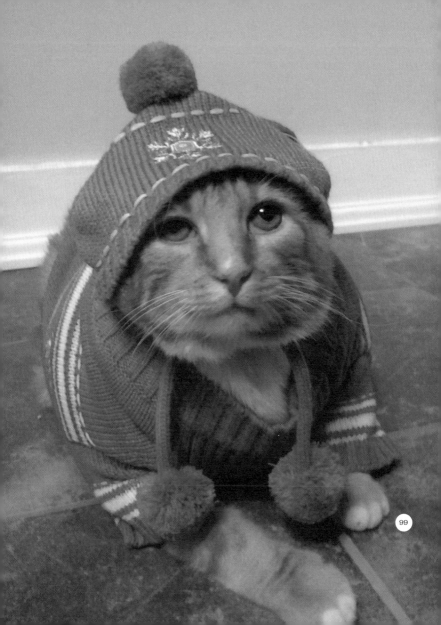

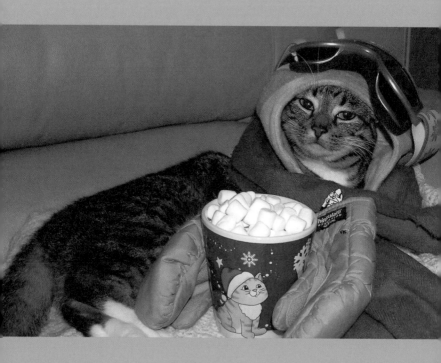

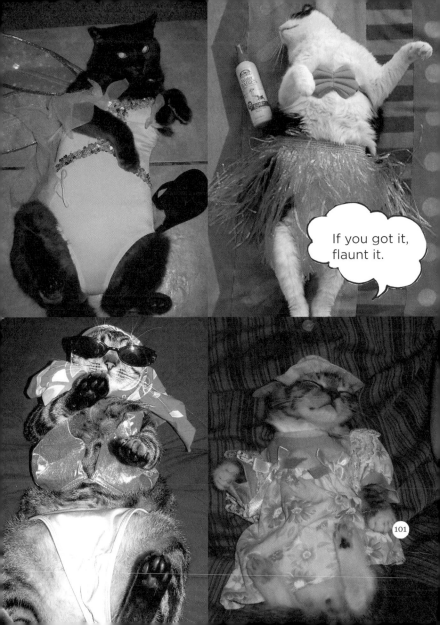

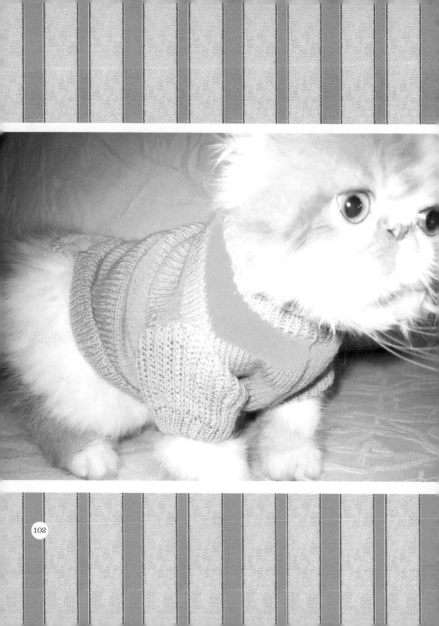

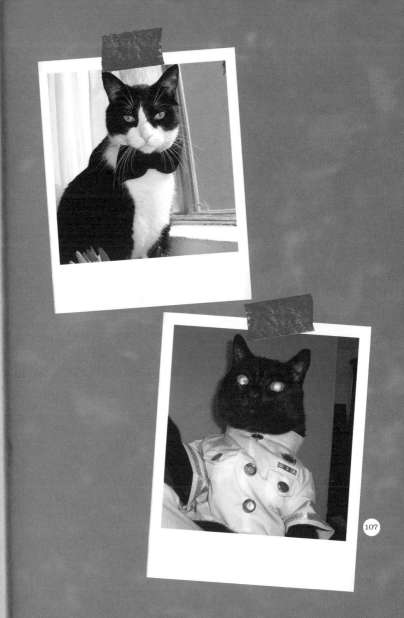

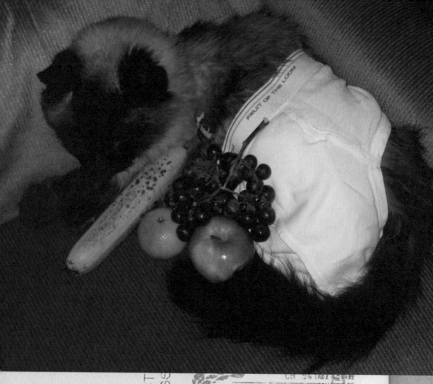

$0.320 $0.320 $0.320
$0.320 ✦ METER
MHR 04 98 3802957

Boxers or briefs? What's your preference?
Eighteen-year-old Snickers adds his vote to
this age-old debate. And as all discerning felines can
tell you, *Fruit of the Loom* is the way to go when

choosing your tightie whities.

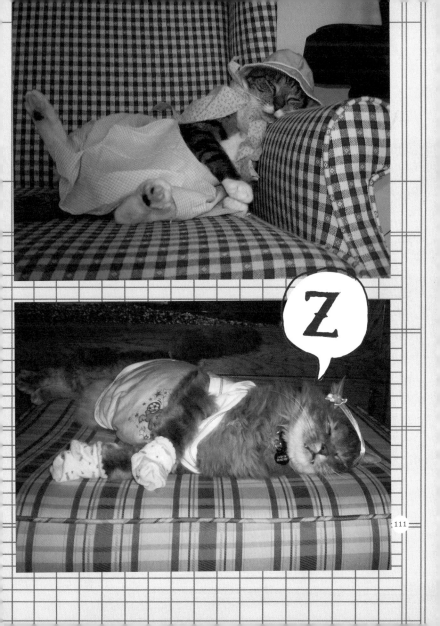

111

Excuse me, there's a hair in my salad.

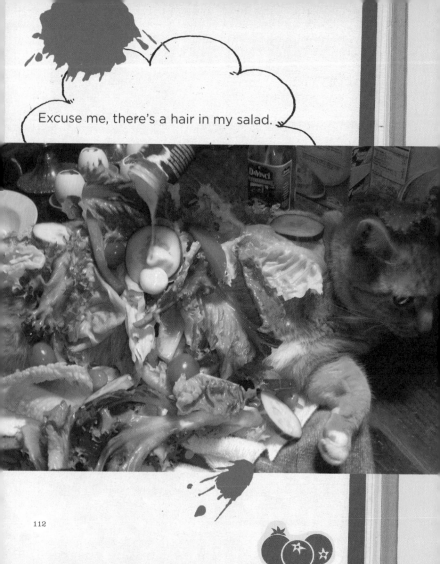

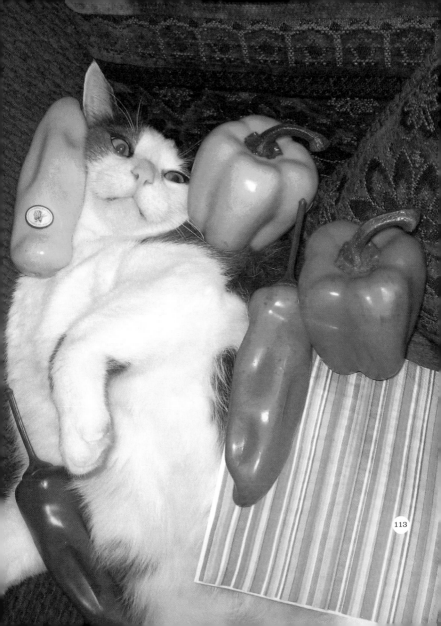

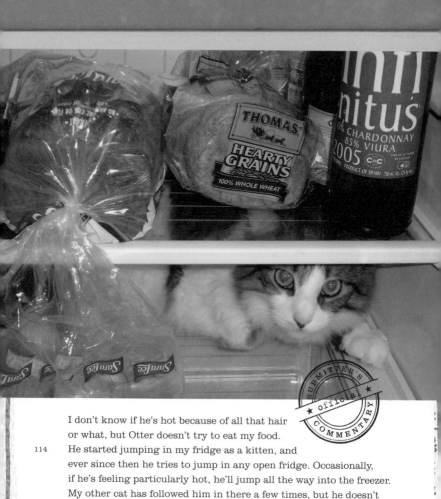

I don't know if he's hot because of all that hair
or what, but Otter doesn't try to eat my food.

114 He started jumping in my fridge as a kitten, and
ever since then he tries to jump in any open fridge. Occasionally,
if he's feeling particularly hot, he'll jump all the way into the freezer.
My other cat has followed him in there a few times, but he doesn't
get the appeal.

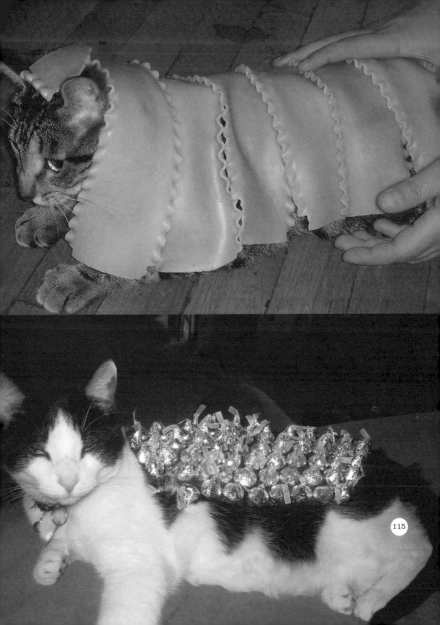

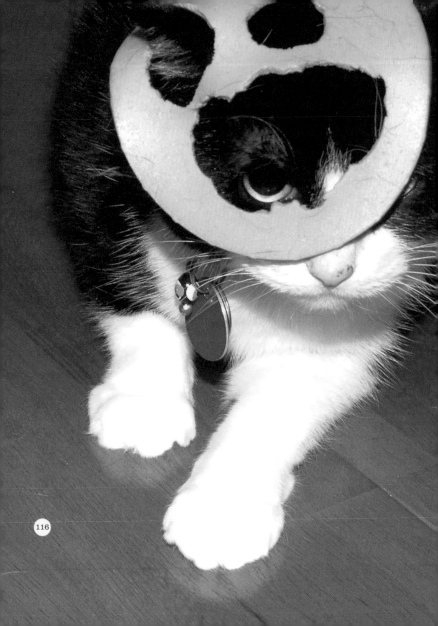

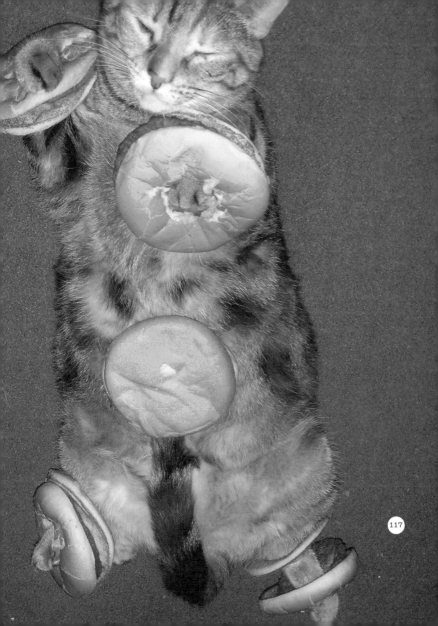

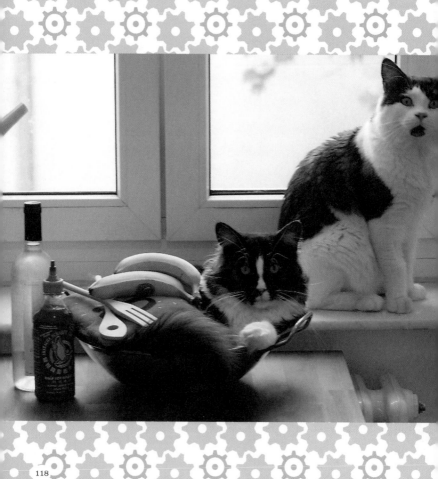

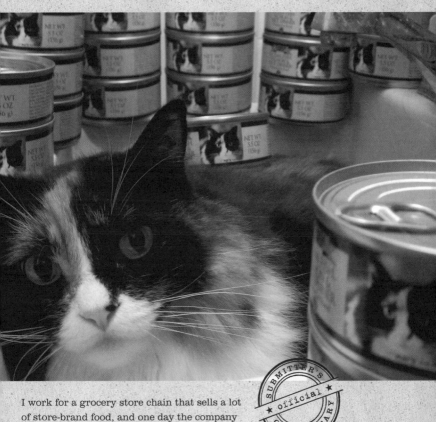

I work for a grocery store chain that sells a lot of store-brand food, and one day the company announced that it was looking for employee pets to put on its pet food labels. I entered, and voilà! Mary-Hannah is a supermodel!

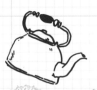

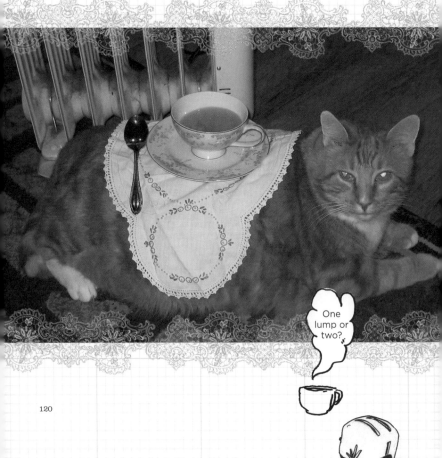

One
lump or
two?

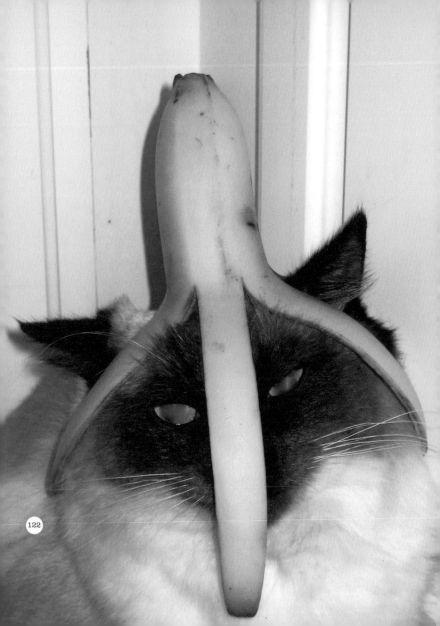

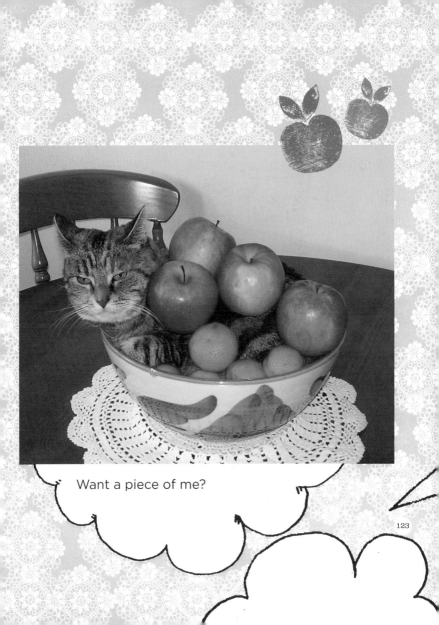

Want a piece of me?

123

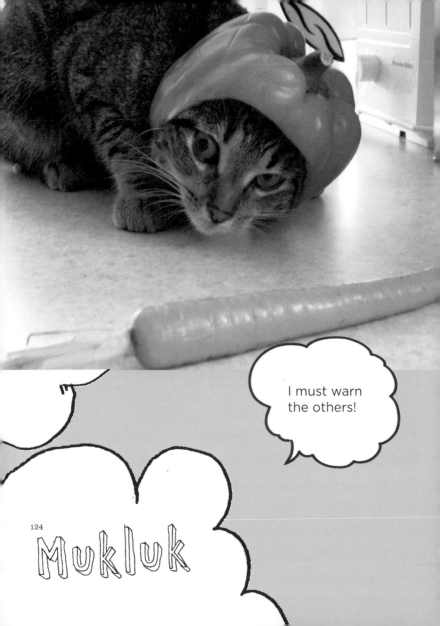

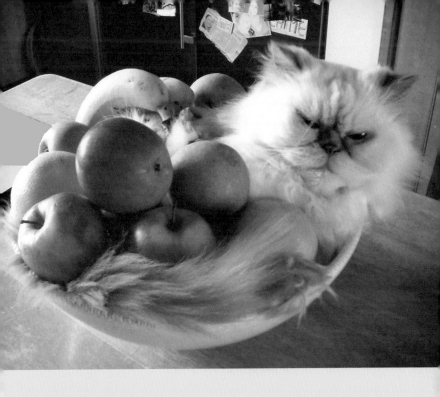

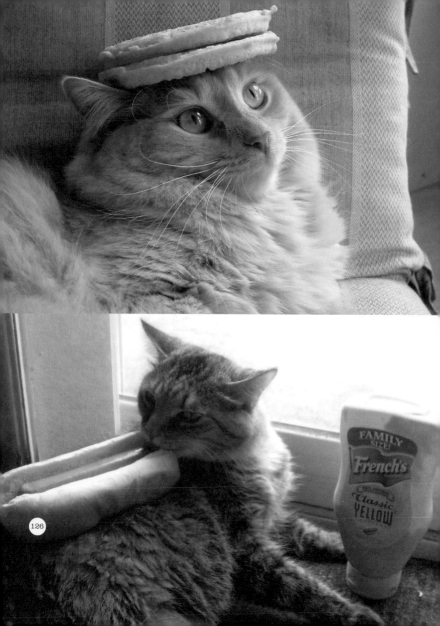

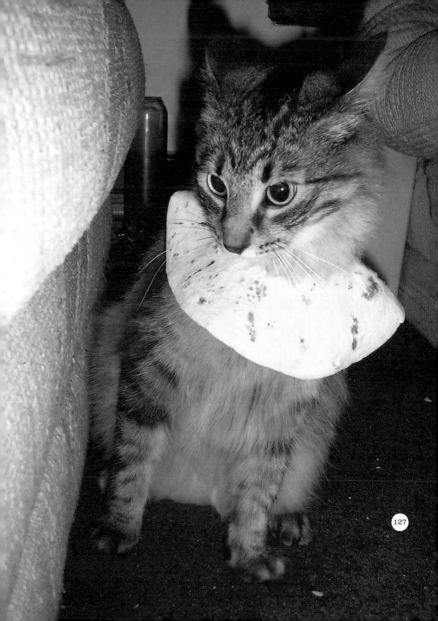

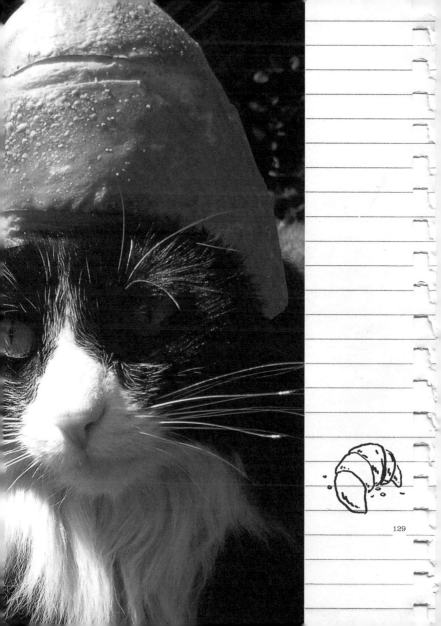

129

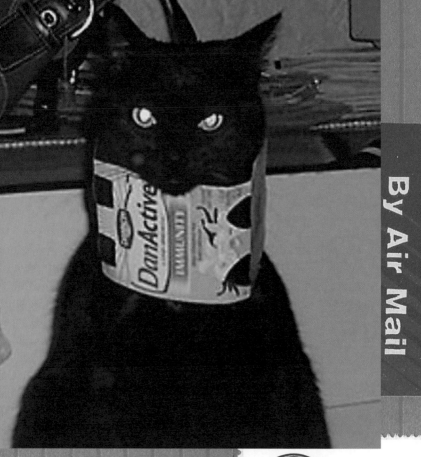

Received Unsealed

SUBMITTER'S
★ official ★
COMMENTARY

She did this herself . . . she
just stuck her head right in.

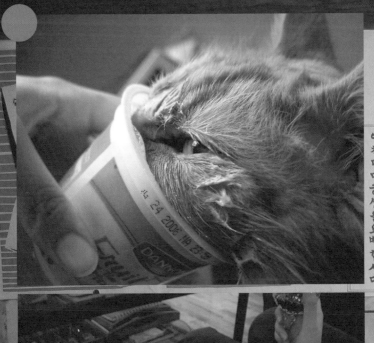

아침마다 궁성을 요배합시다

131

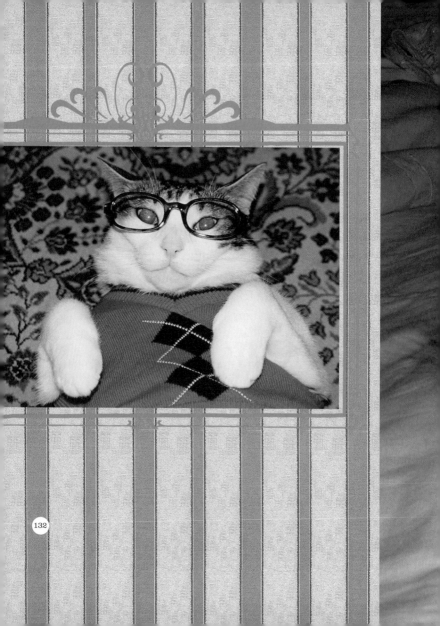

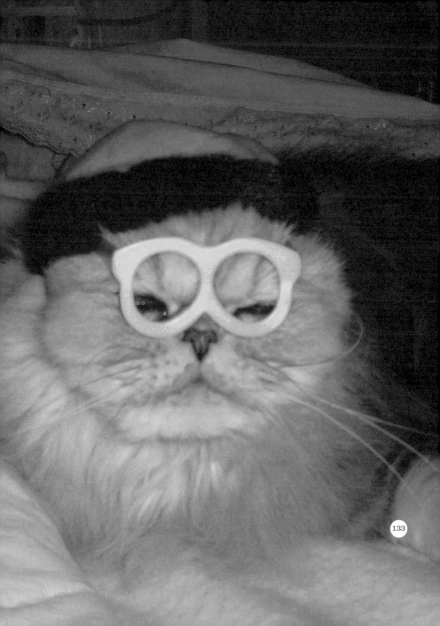

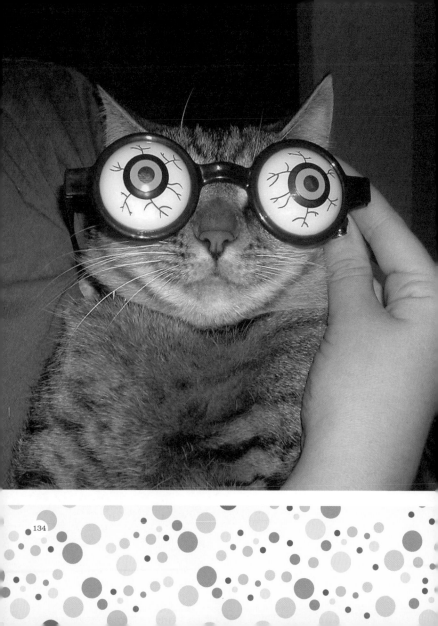

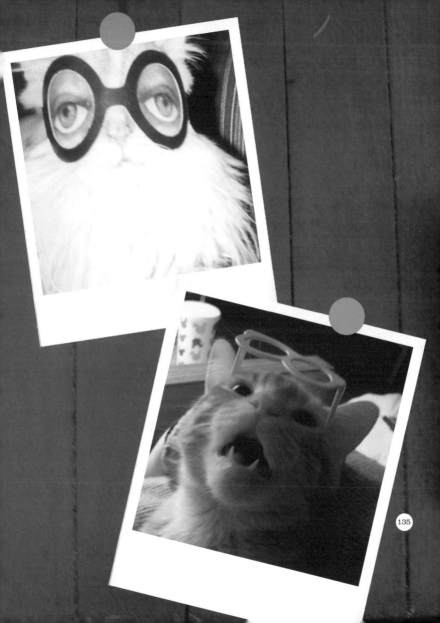

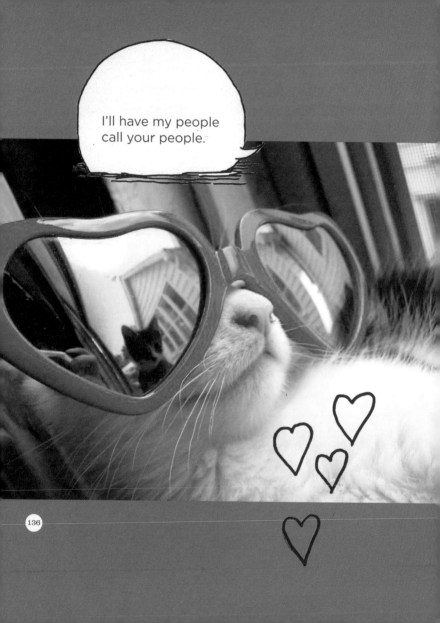

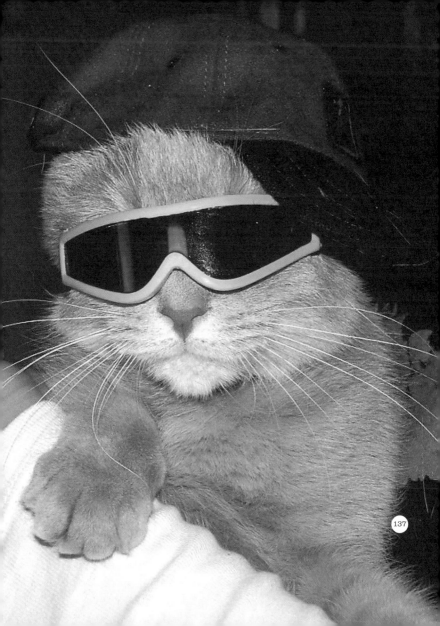

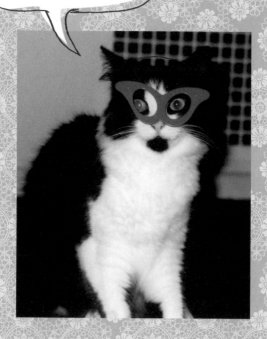

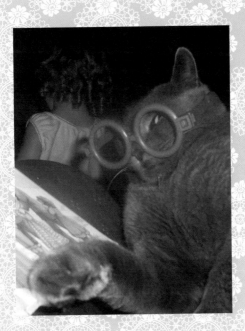

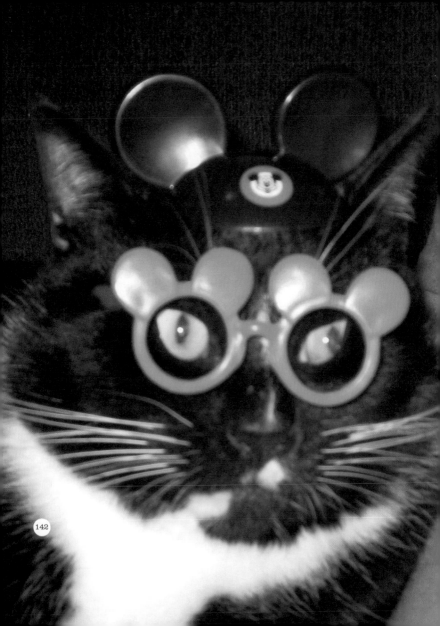

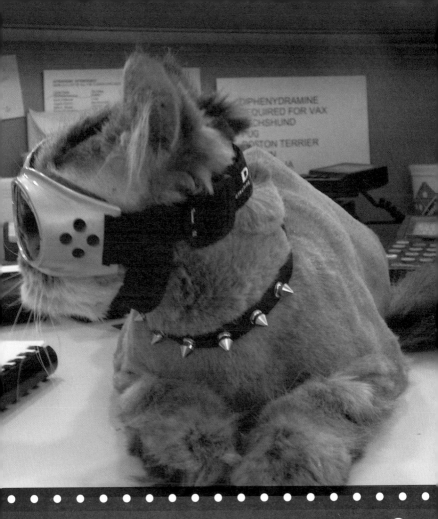

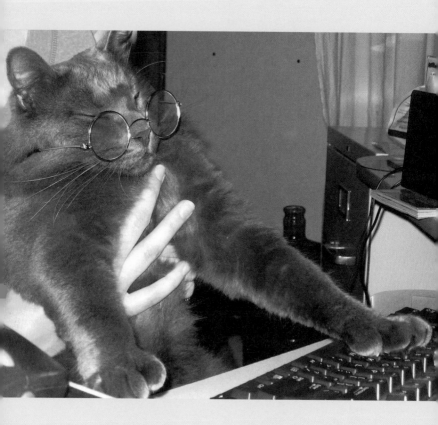

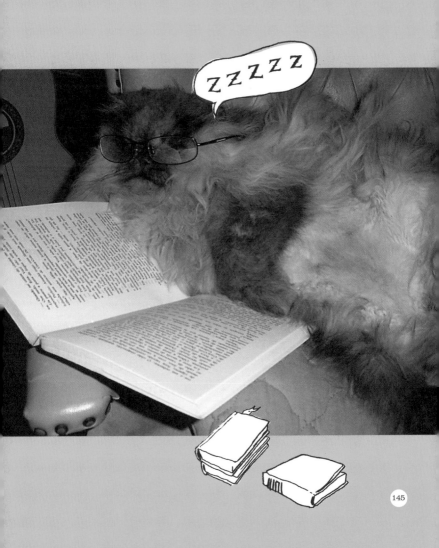

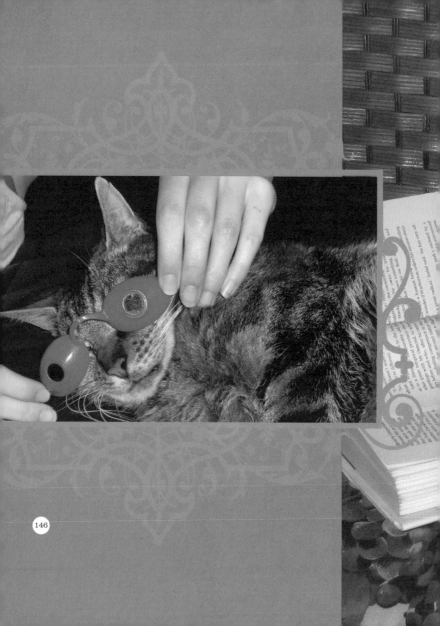

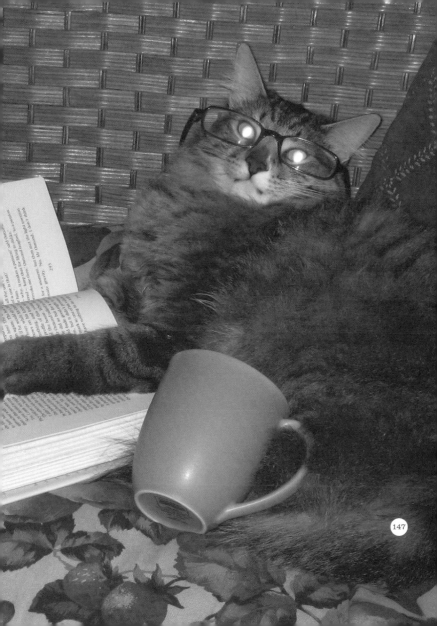

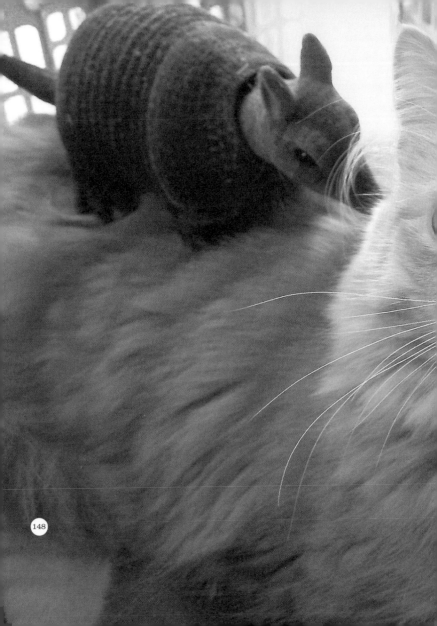

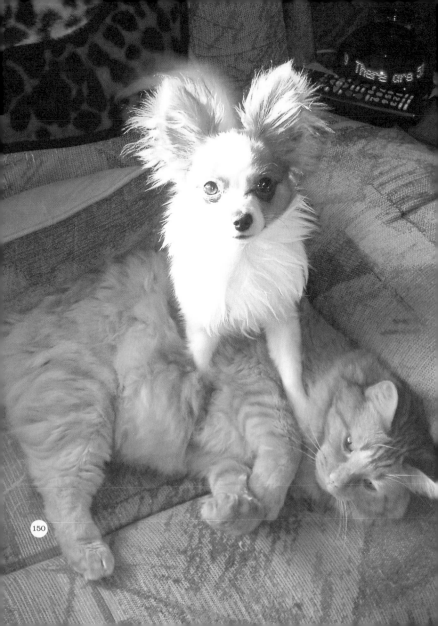

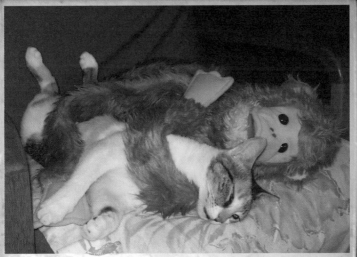

Cali hardly noticed when this monkey snuck up and wrapped his arms around her. This is one of her favorite positions for napping when it's hot—twisted around with legs in the air. Guess it lets the tummy cool off a bit?

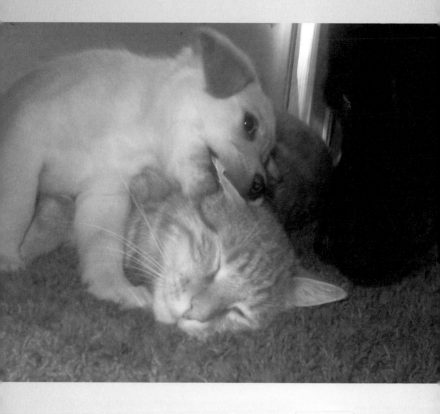

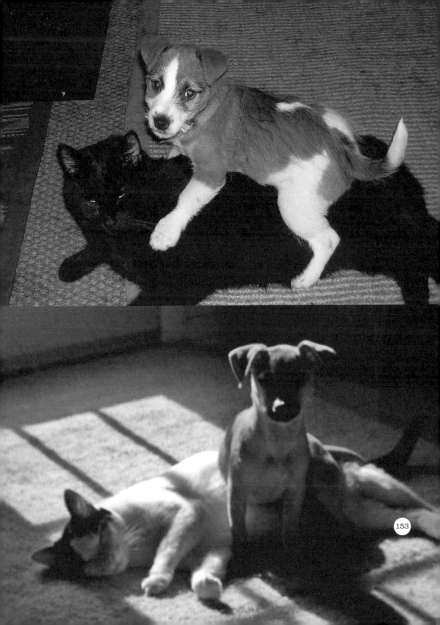

153

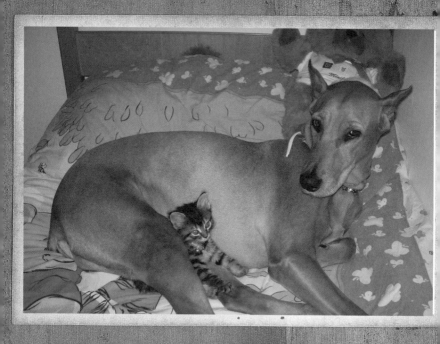

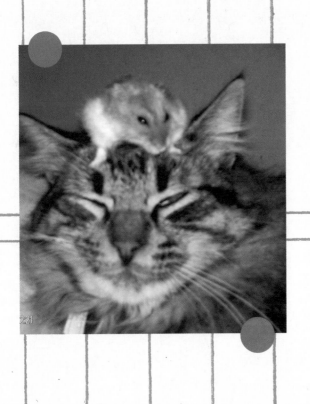

221

155

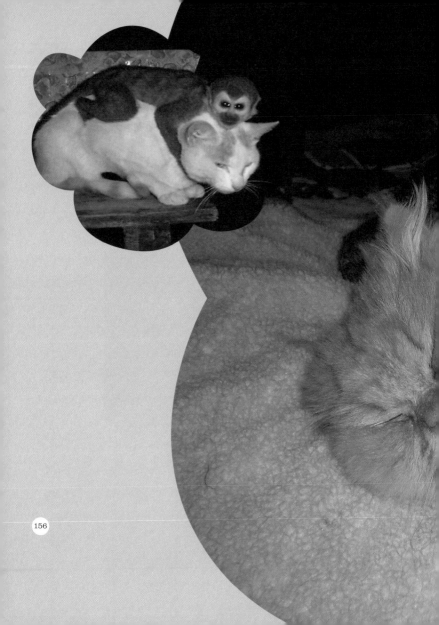

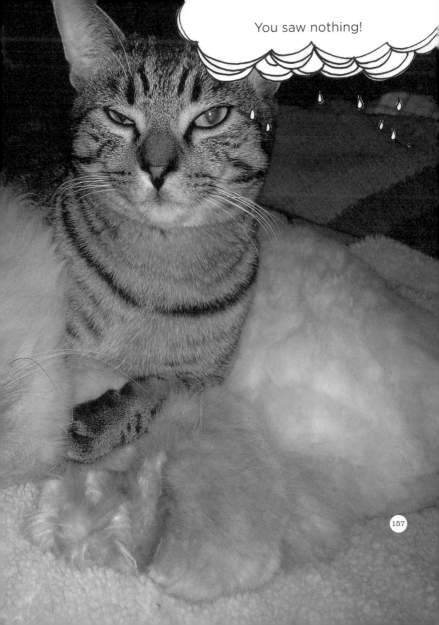

This is Sunky. Usually, Sunky ambushes Cow wherever we have hidden him, grabs him by the scruff of the neck, and runs with him through her little kitty door into her bathroom lair. This evening, however, Sunky and Cow were able to

reconcile their differences, due to their common love of grass-grazing.
You can see how Cow stealthily approached the demon-eyed Sunky and
whispered that she should partake of the delectable grass, and how
Sunky willingly complied.

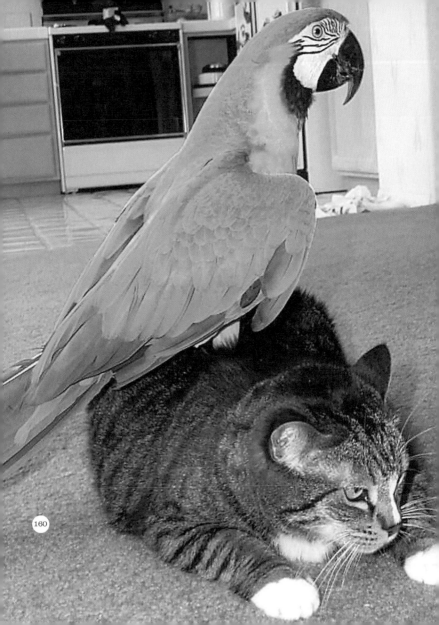

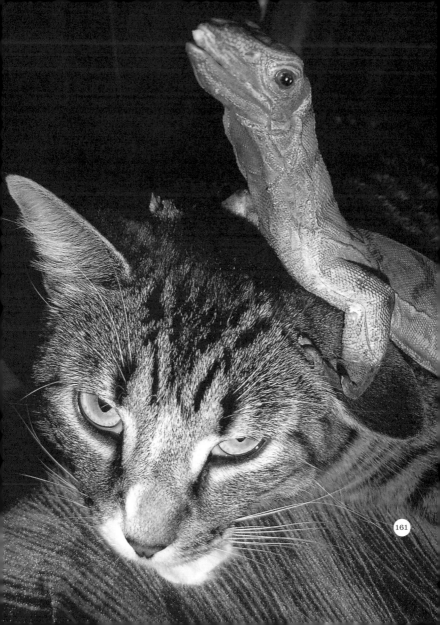

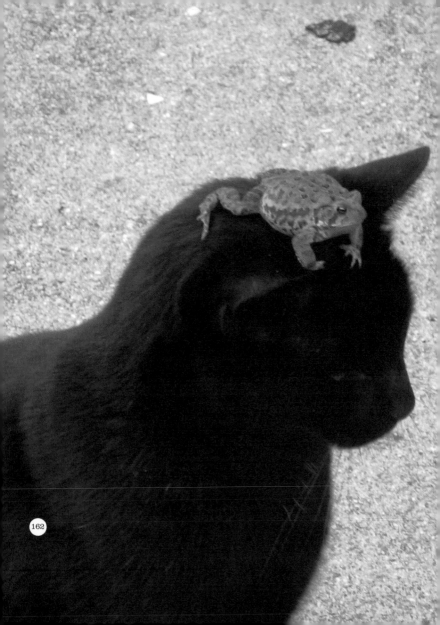

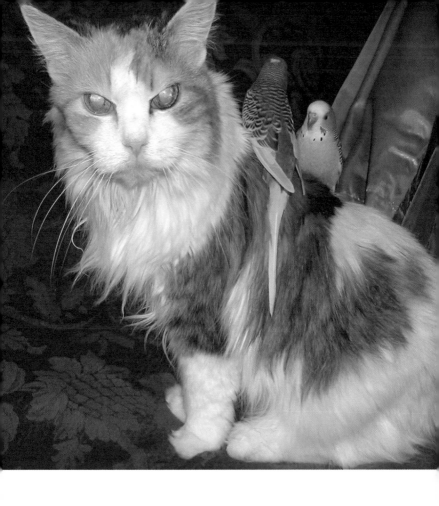

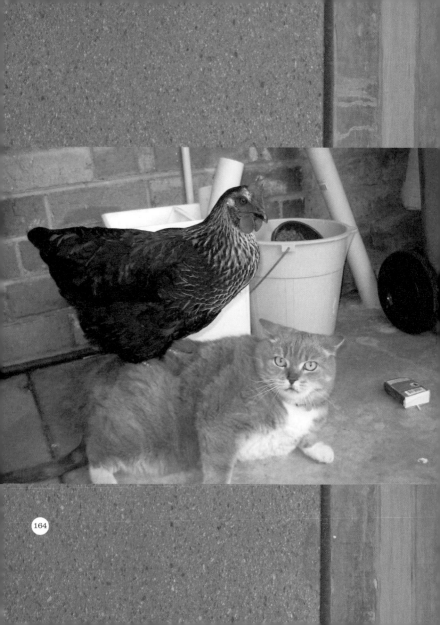

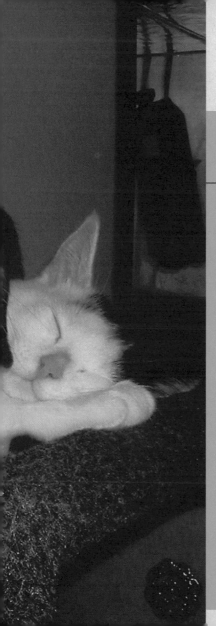

Pixie Kitten and Rascal Rabbit are the best of friends. They go everywhere together, getting into all sorts of mischief. I often find them egging each other on when trying to tip over the kitchen bin or getting the biscuit tin to fall off the shelf, making biscuits go everywhere. They always look so innocent when I catch them in the act that I can't get mad! Who could with these two?

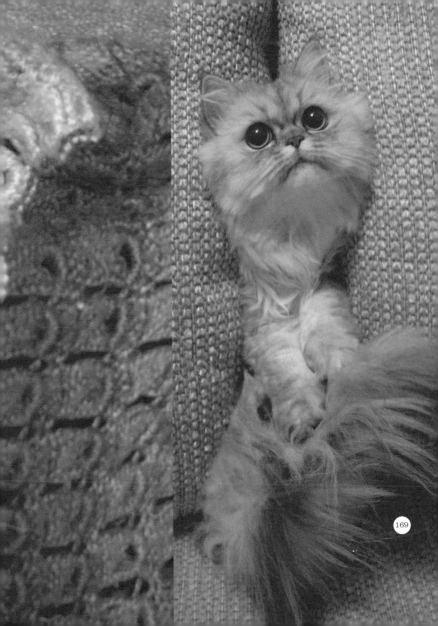

Boo is a five-year-old calico who currently weighs in at twenty pounds. She hasn't always been like this, though—she was a petite cat for the first few years of her life. That all changed when she was fixed. She stopped caring what she looked like and she has really let herself go.

My brother likes to refer to her as "Big Fat Baby Boober." My sister-in-law says she's just big-boned.

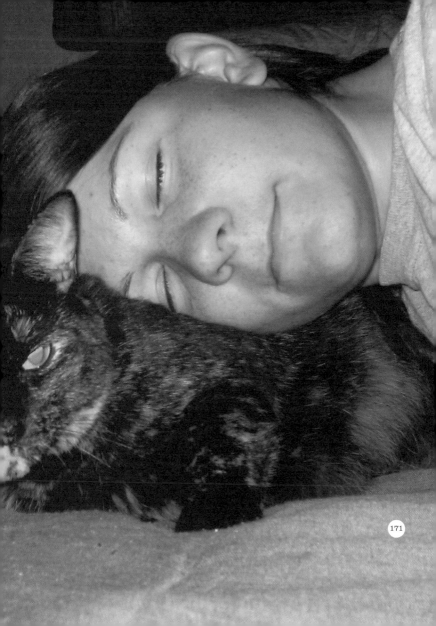

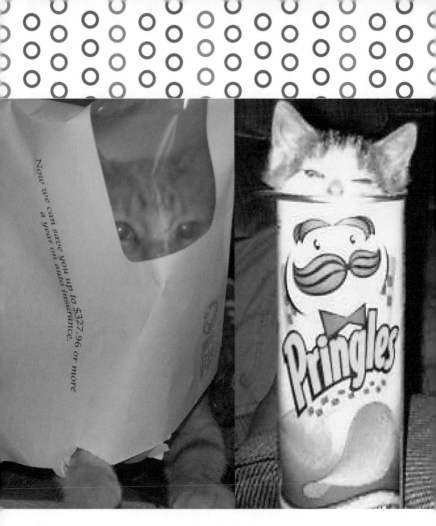

Now we can save you up to $327.96 or more a year on auto insurance.

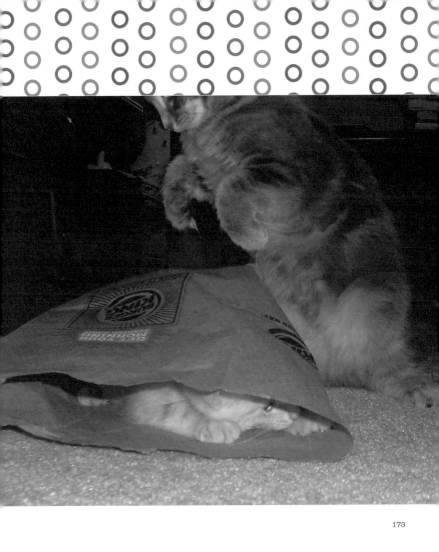

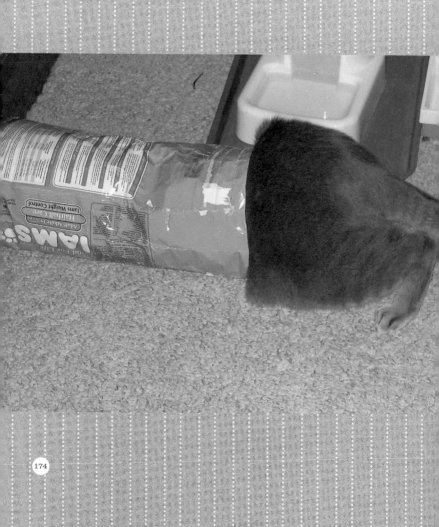

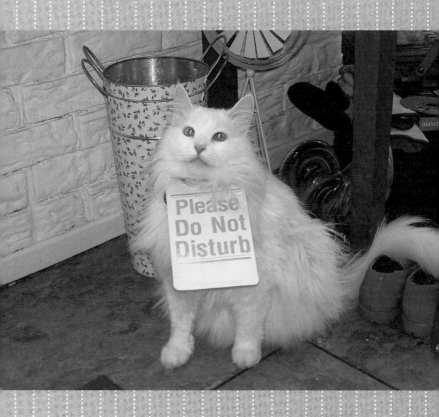

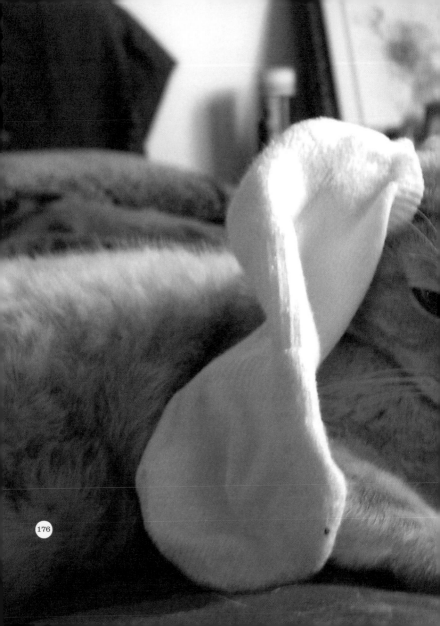

You wear them like this, right?

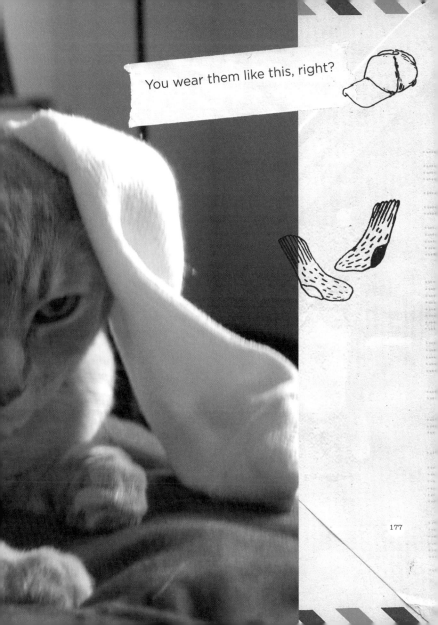

178

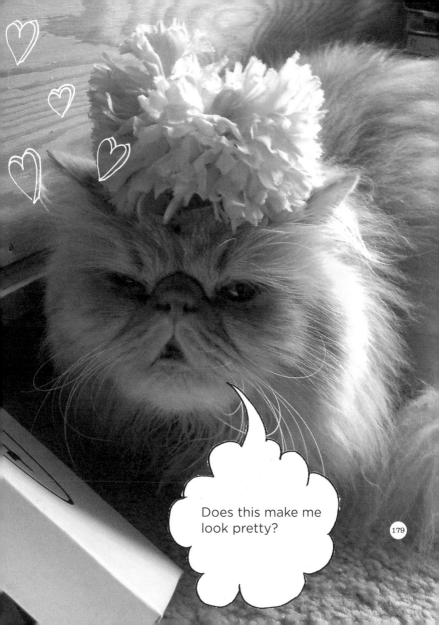

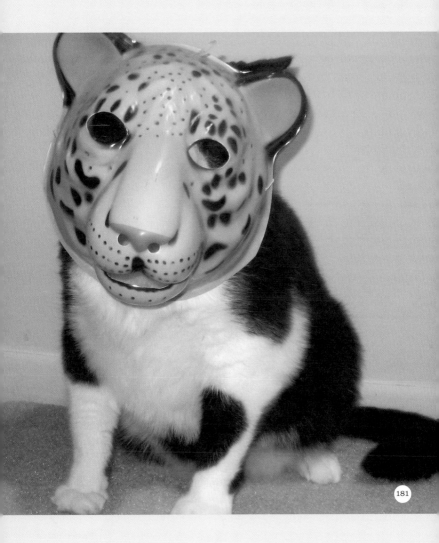

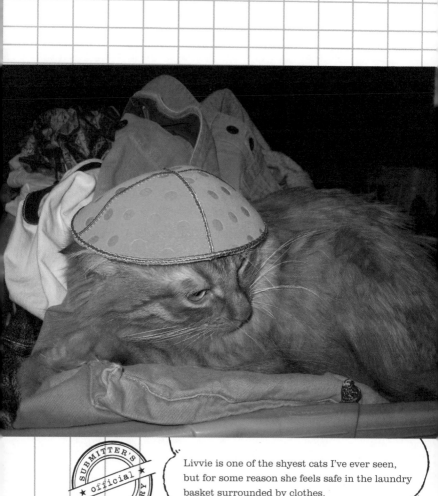

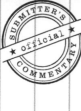

Livvie is one of the shyest cats I've ever seen, but for some reason she feels safe in the laundry basket surrounded by clothes.

This is Mister. He hates it and runs away if we try to put stuff on him. But this day, he surrendered to the smelly Silly Putty trick.

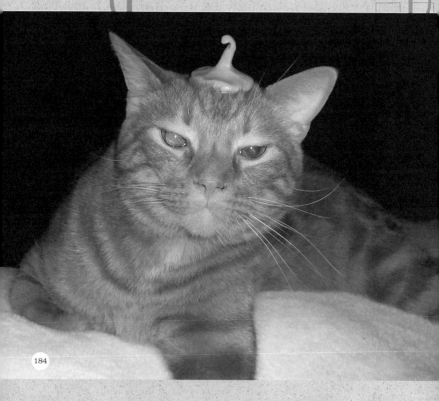

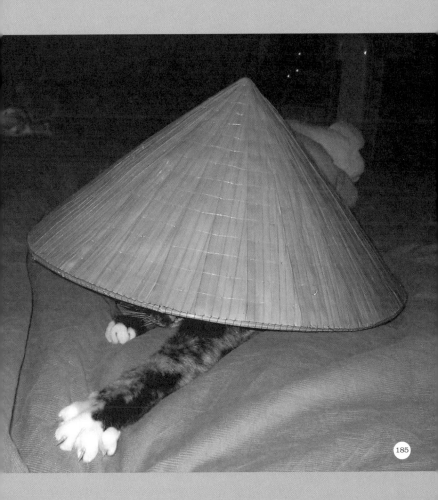

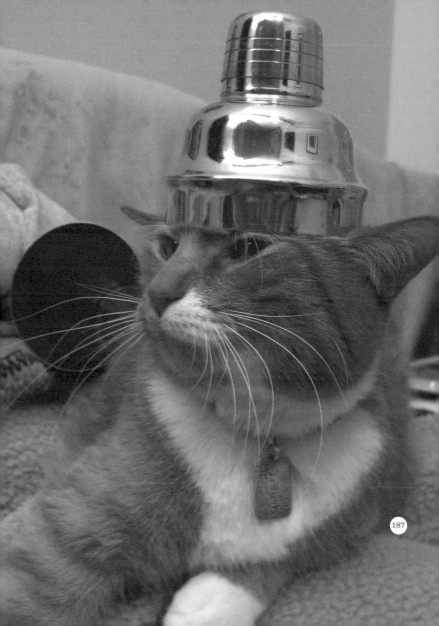

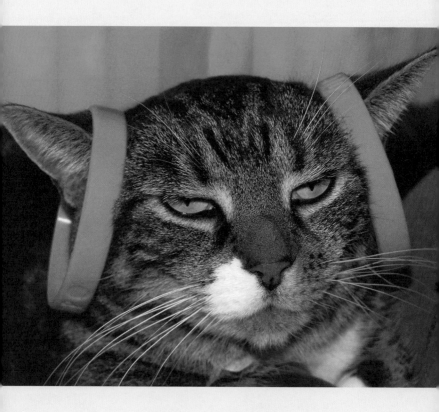

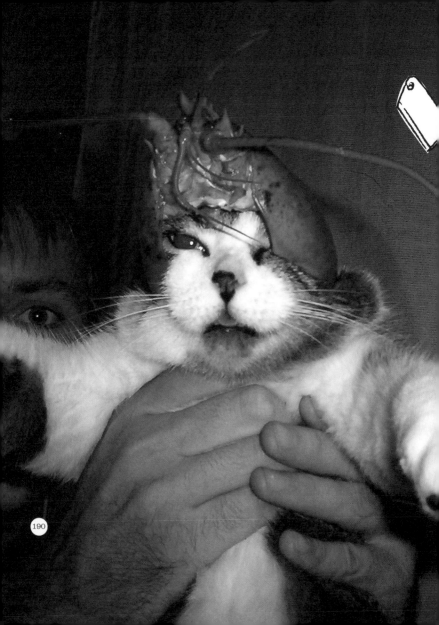

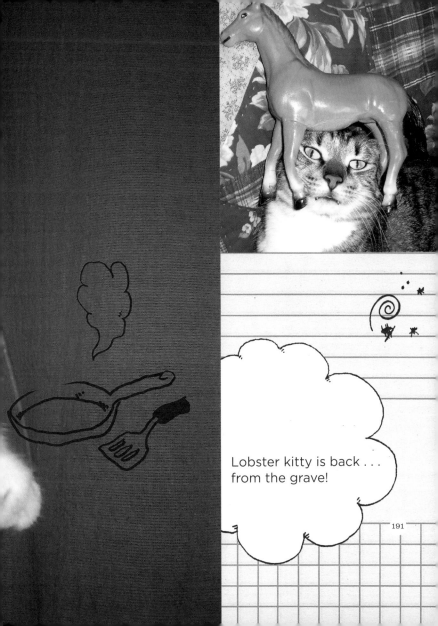

Lobster kitty is back . . .
from the grave!

191

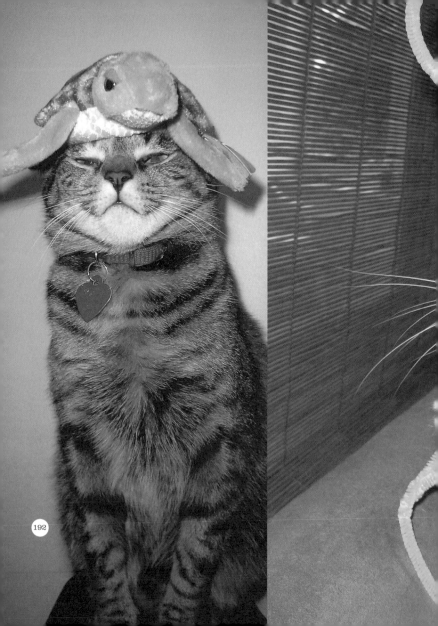

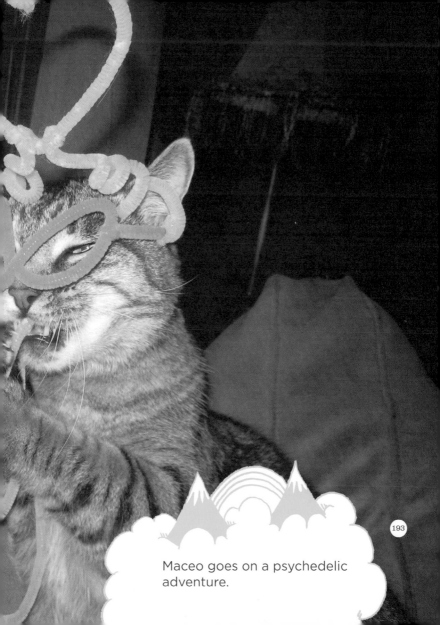

Maceo goes on a psychedelic adventure.

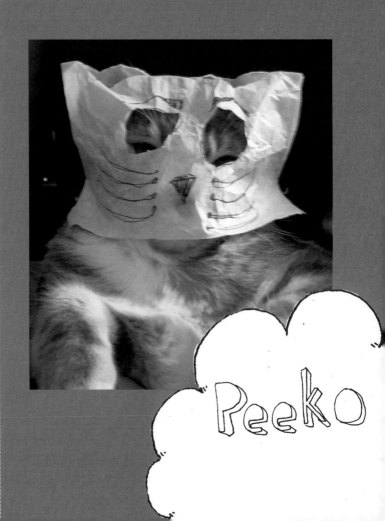

Peeko

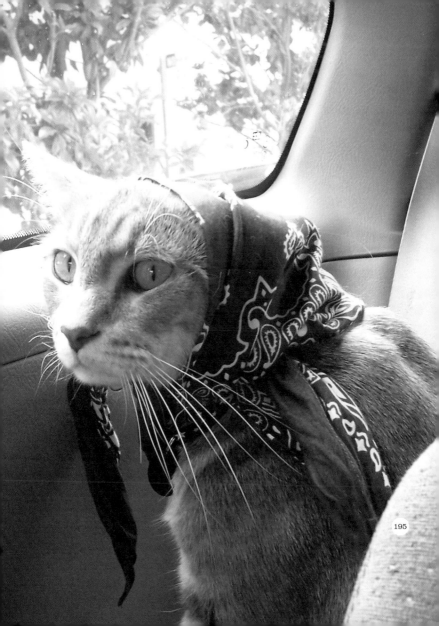

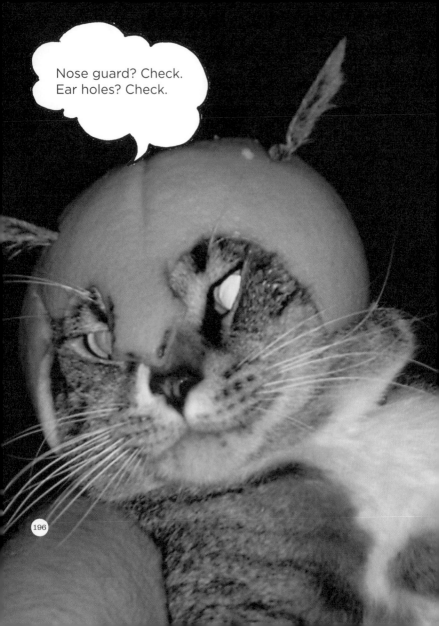

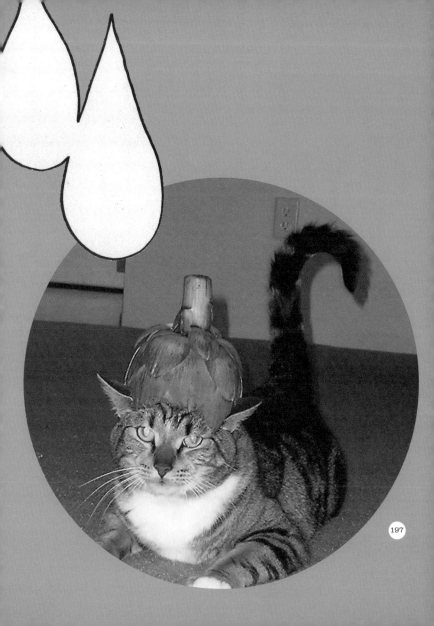

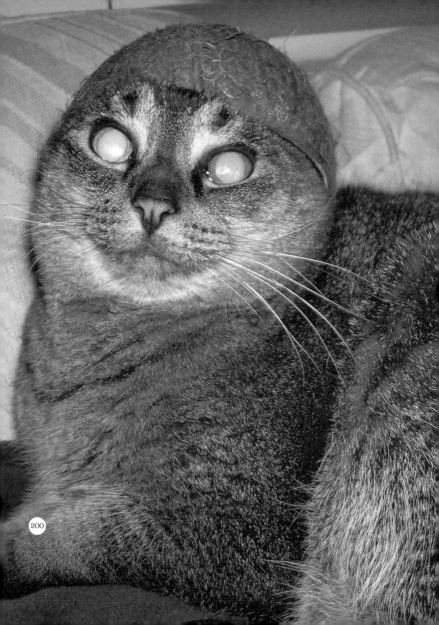

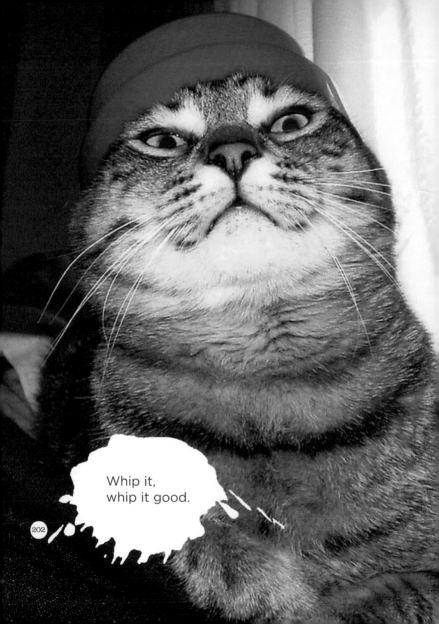

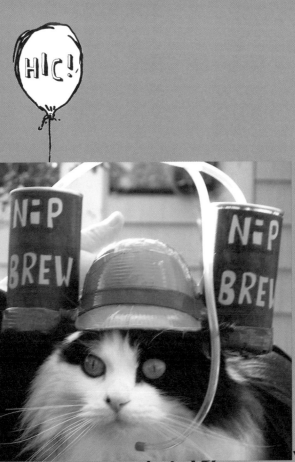

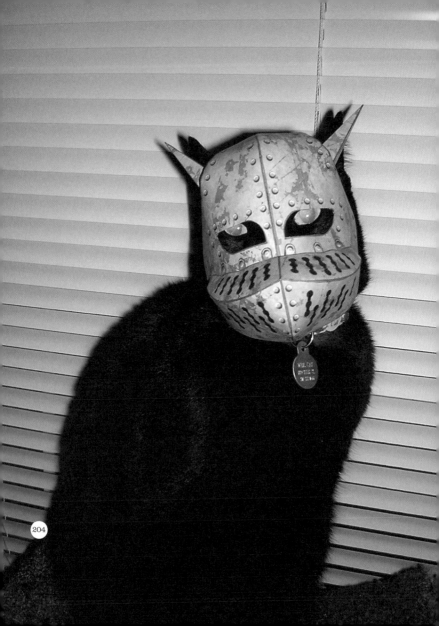

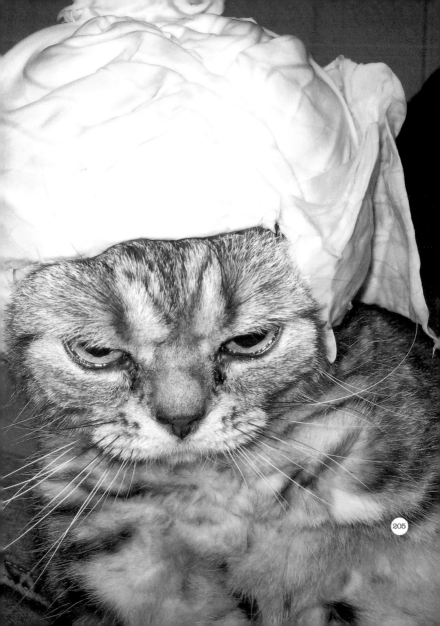

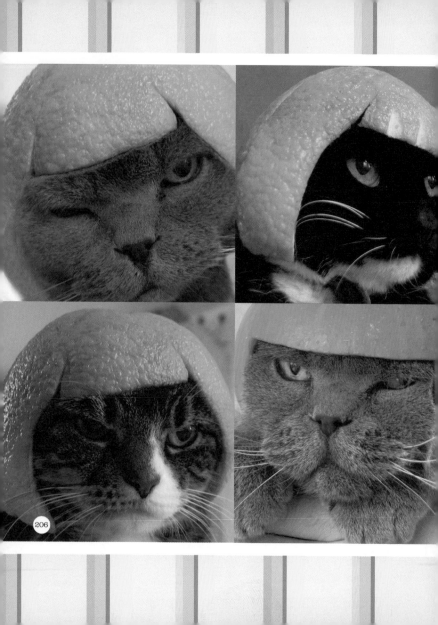

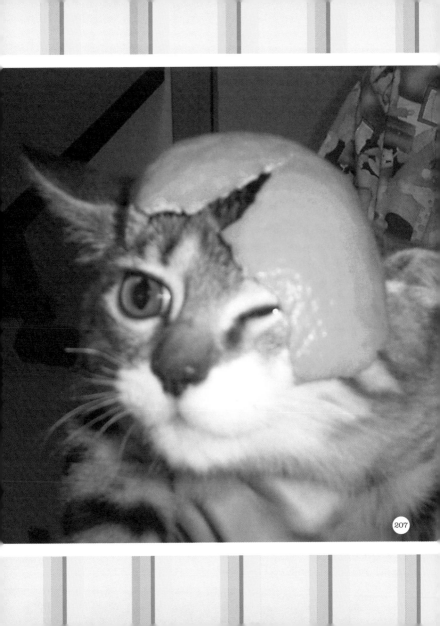

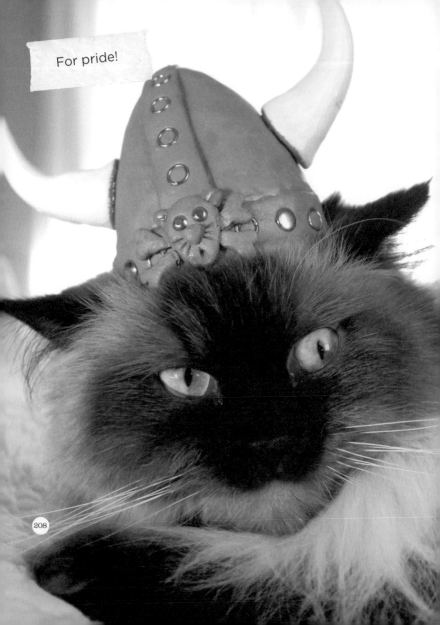

For pride!

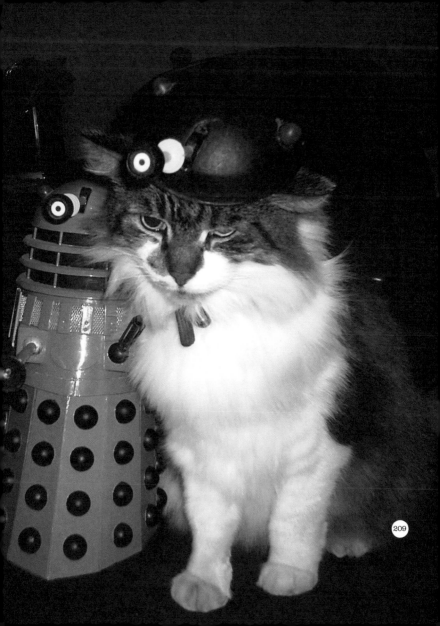

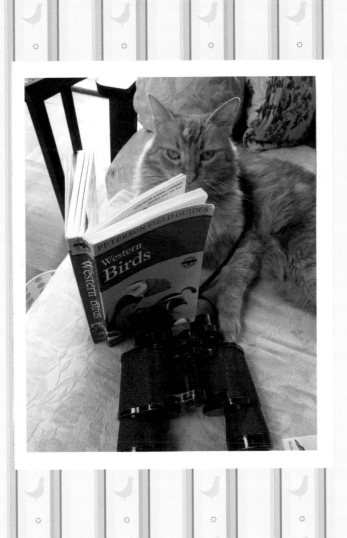

C is for Communism on Claudia!

I work at a diamond mine in the Arctic, and I am home about ten days out of twenty-eight. I cannot bring my cats to work, and thus, to help a bit with the isolation, I have a huge folder of digital photographs of my two cats in various fun poses.

Yes, that is really a bust of Lenin. It looks great on a kitty, doesn't it? I really think Claudia has captured the Cold War spirit well!

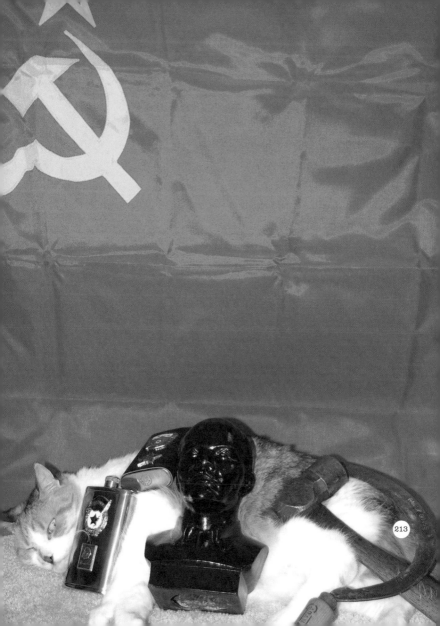

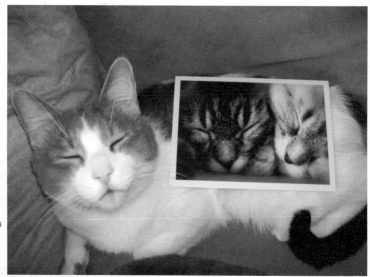

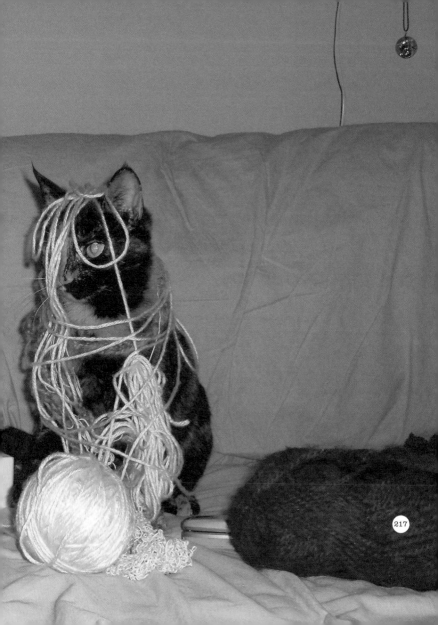

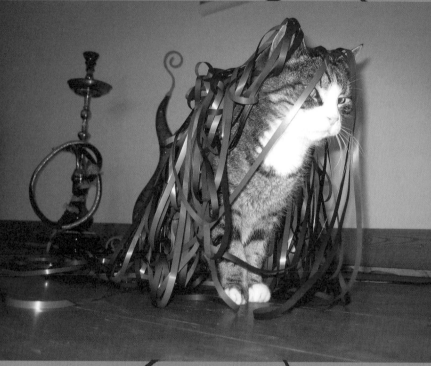

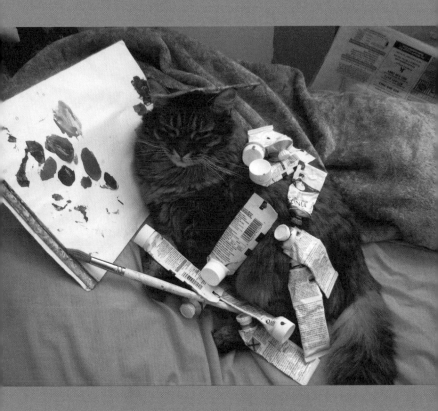

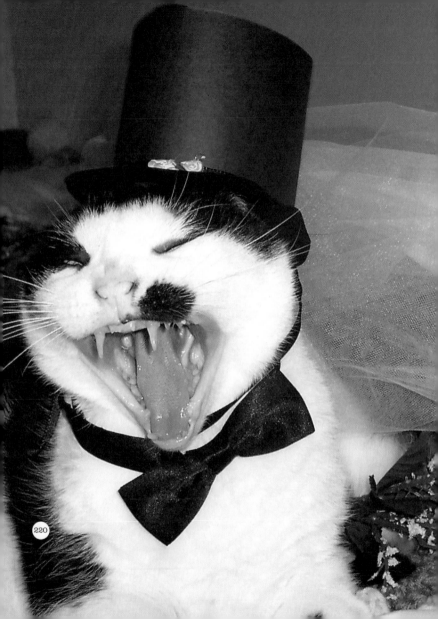

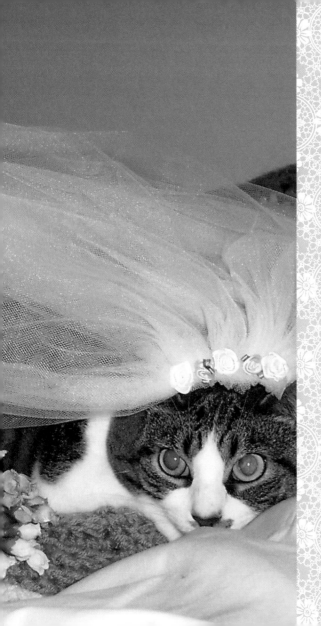

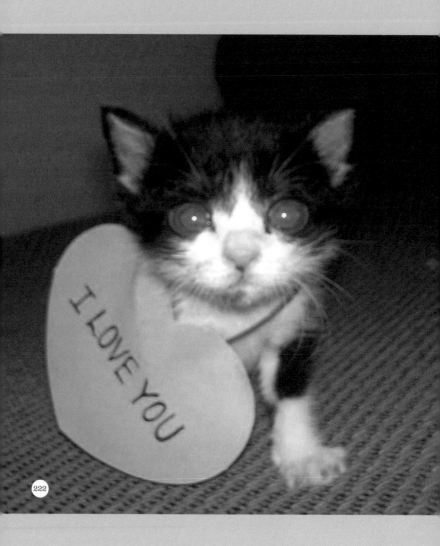

I LOVE YOU

222

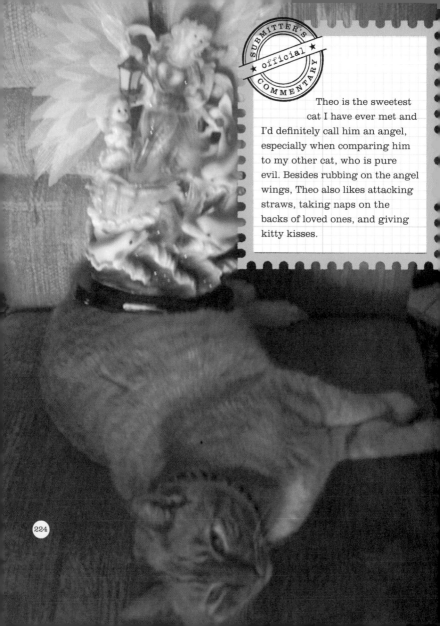

Theo is the sweetest cat I have ever met and I'd definitely call him an angel, especially when comparing him to my other cat, who is pure evil. Besides rubbing on the angel wings, Theo also likes attacking straws, taking naps on the backs of loved ones, and giving kitty kisses.

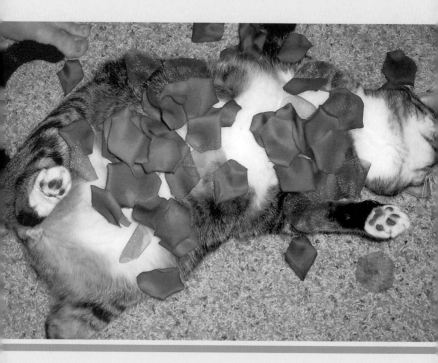

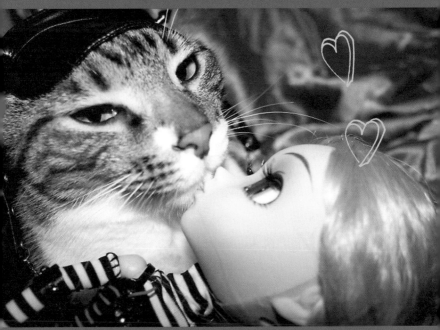

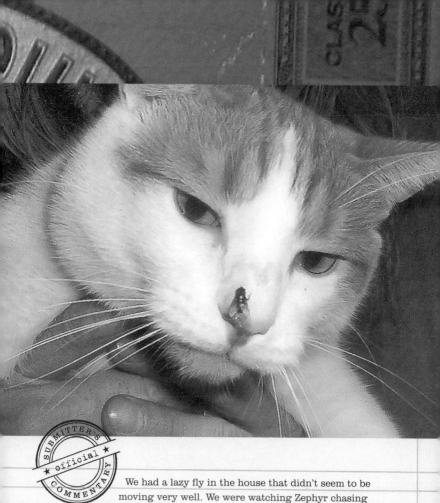

SUBMITTER'S official COMMENTARY

We had a lazy fly in the house that didn't seem to be moving very well. We were watching Zephyr chasing it around the house, when it suddenly landed **right on his nose!** We were cracking up and couldn't believe it when it stayed there for several minutes. It stopped Zephyr cold . . . he was totally thrown for a loop and didn't know what to do. The baffled expression on his face as he was trying to look cross-eyed at it was priceless.

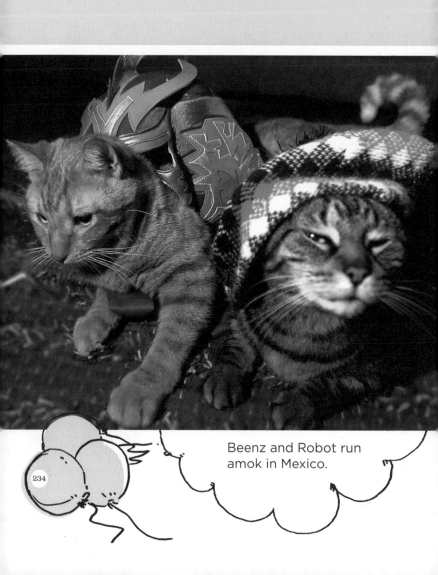

Beenz and Robot run amok in Mexico.

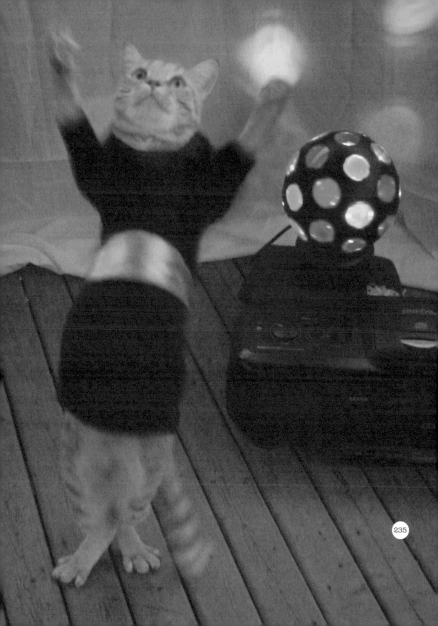

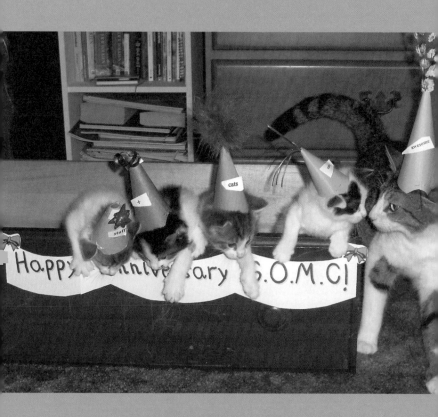

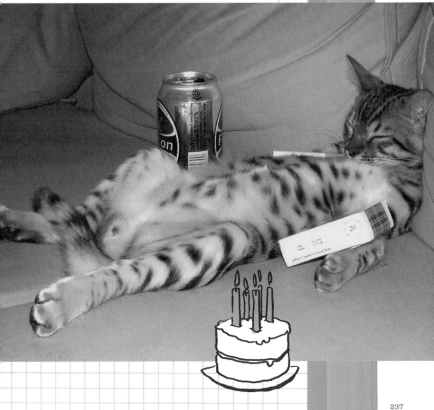

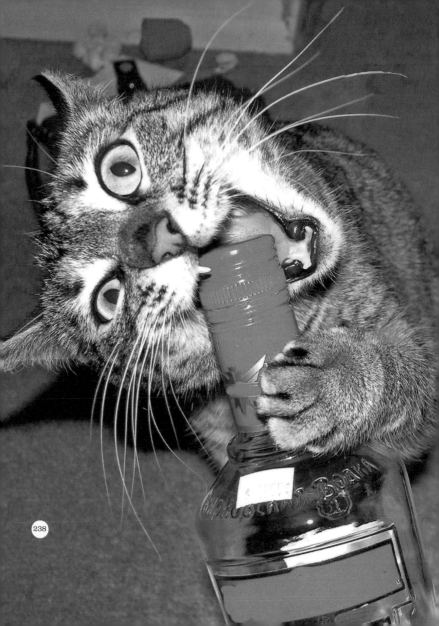

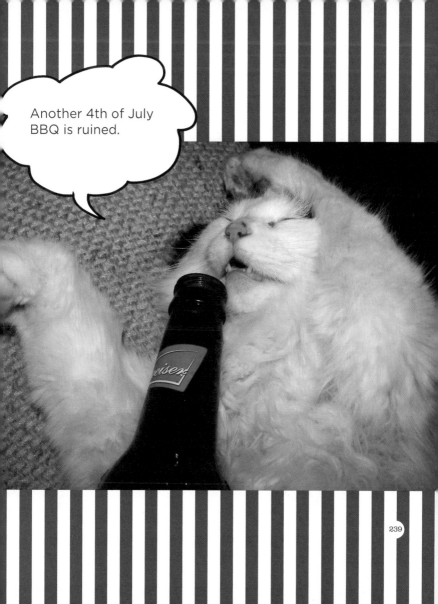

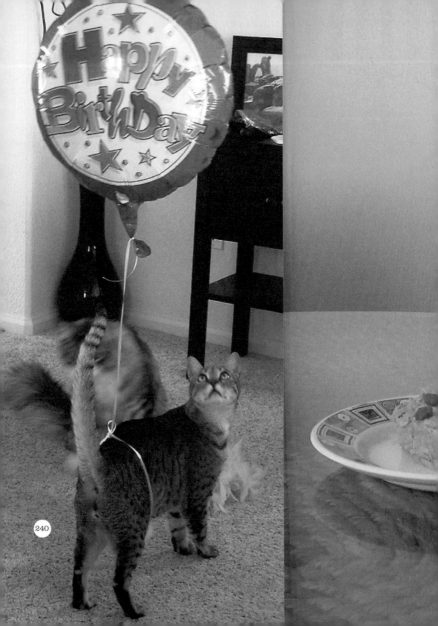

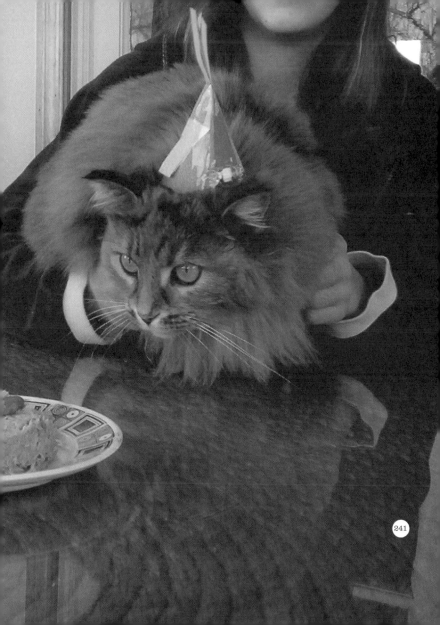

Catnip

PET GOLD.

A FARM FRESH PREMIUM TREAT FOR CATS

Net Wt. 2.0

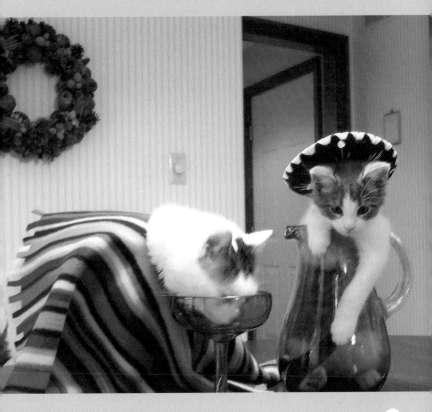

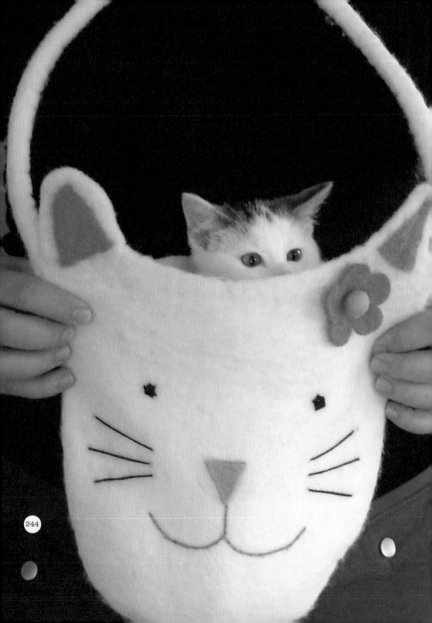

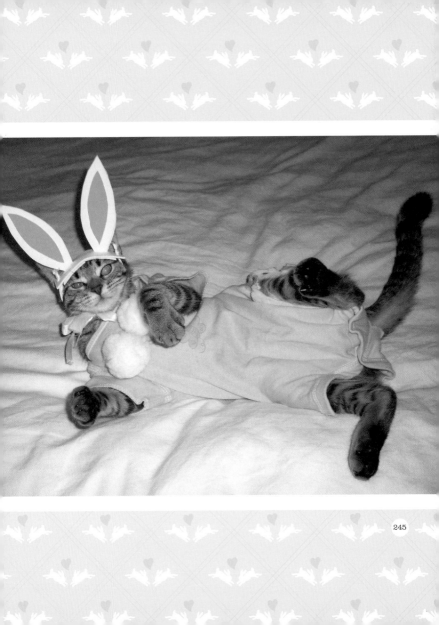

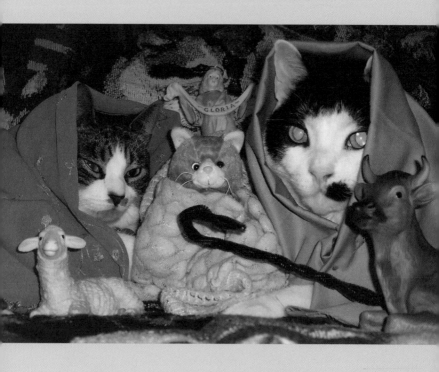

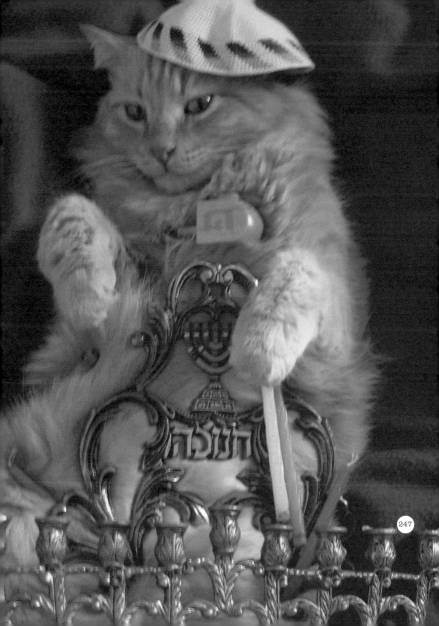

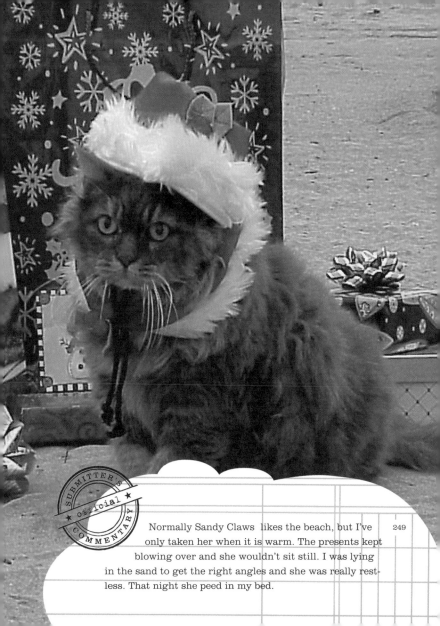

SUBMITTER'S
official
COMMENTARY

Normally Sandy Claws likes the beach, but I've only taken her when it is warm. The presents kept blowing over and she wouldn't sit still. I was lying in the sand to get the right angles and she was really restless. That night she peed in my bed.

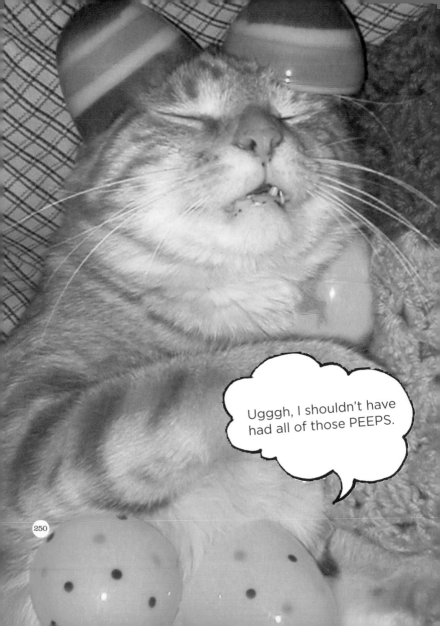

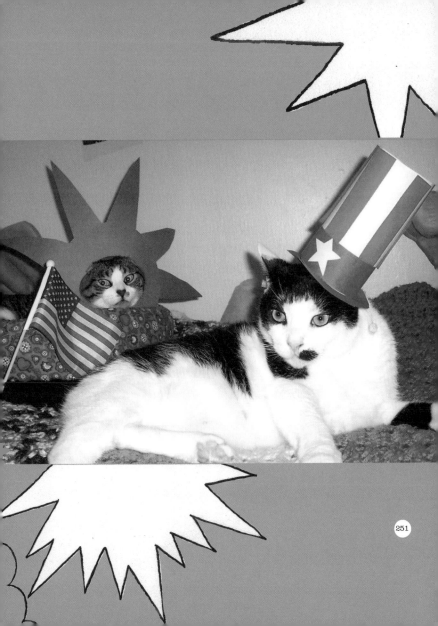

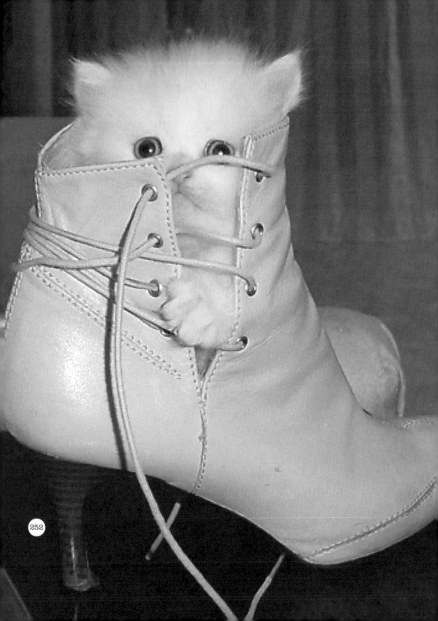

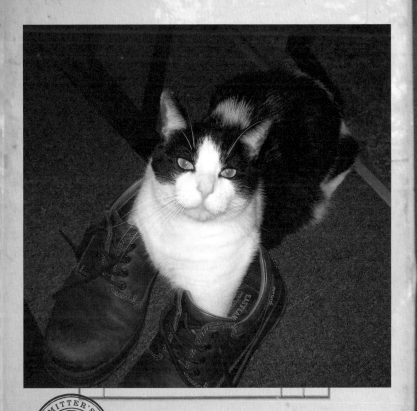

Shamoo is quite the weird little dude, even by cat standards. Take this photo, for example. One night when my husband and I were making dinner, we happened to look down and see Shamoo sitting with his front paws in John's shoes. Mind you, he wasn't playing around and digging for a mousie in the toes, nor was he doing a brief investigation on his way past. He was just sitting there contentedly with shoes on his feet. He only got up because he was embarrassed after I took the fifth photo of him.

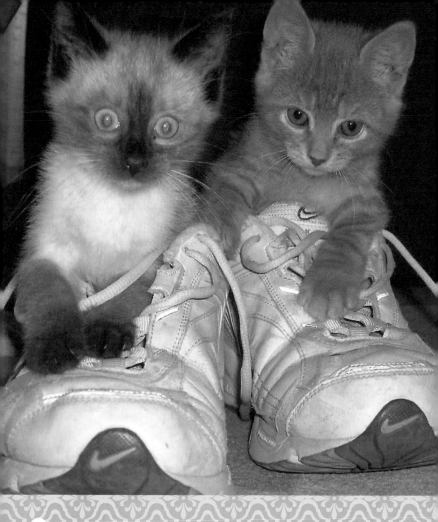

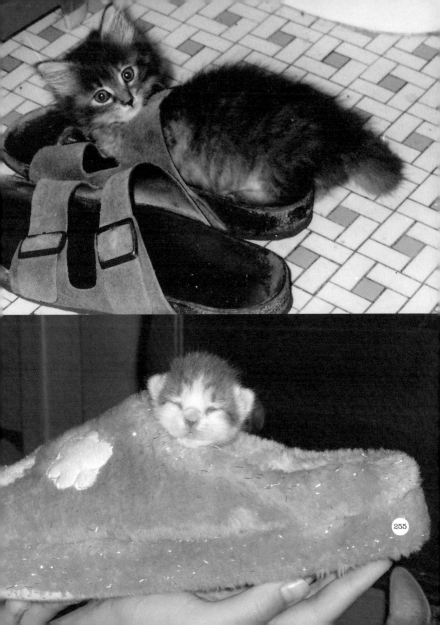

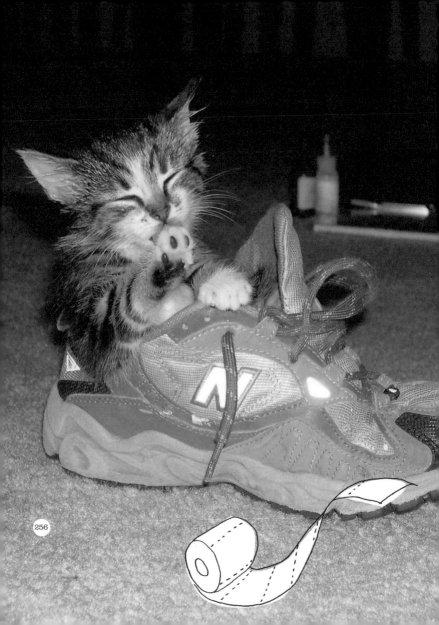

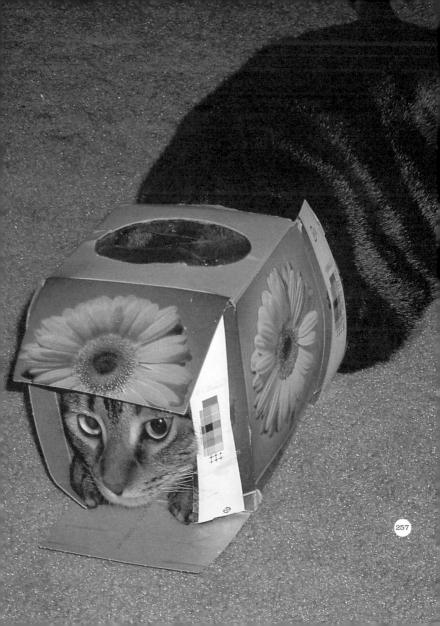

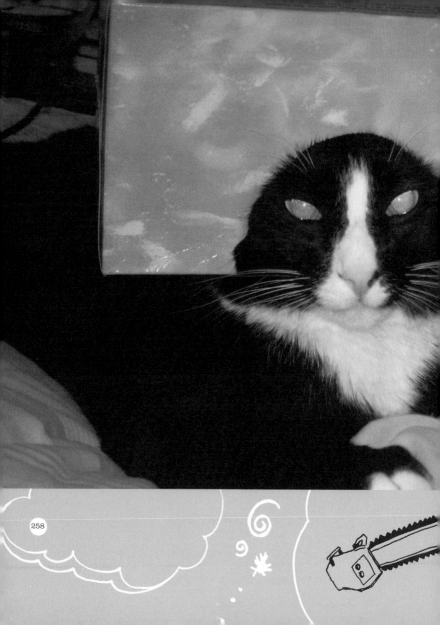

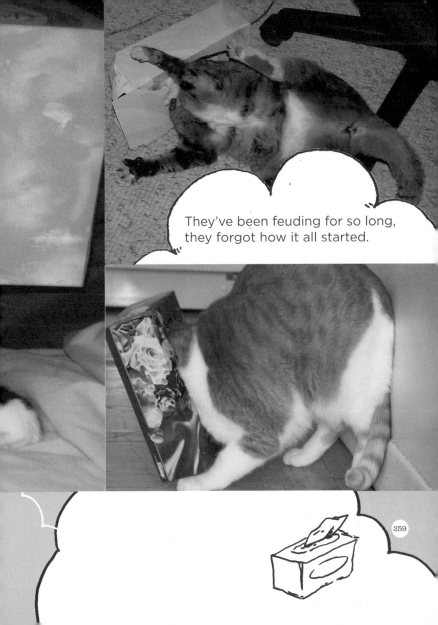

They've been feuding for so long,
they forgot how it all started.

259

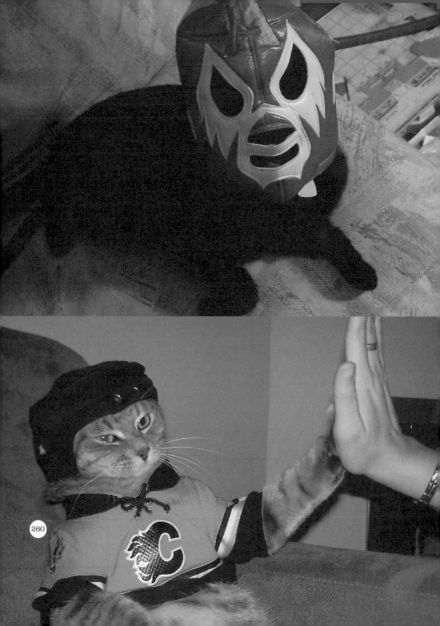

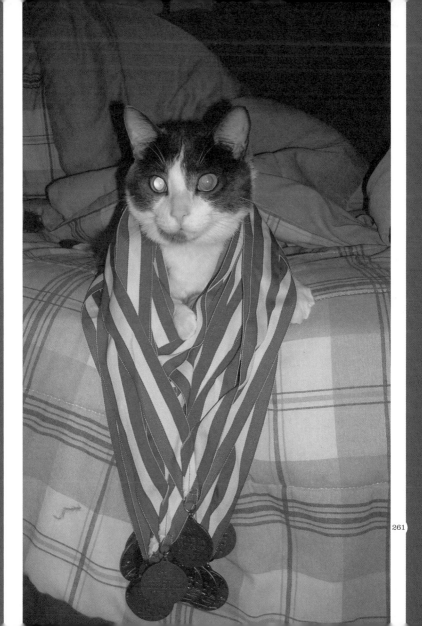

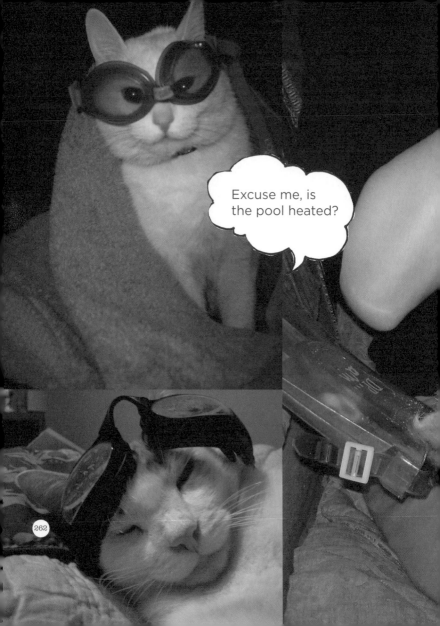

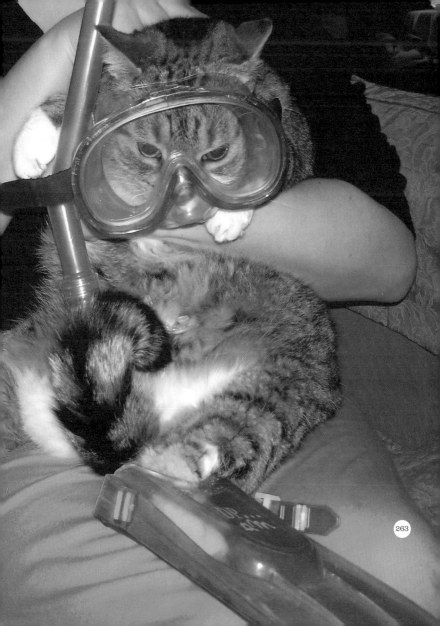

8 | 9 | 10
♠ | ♣

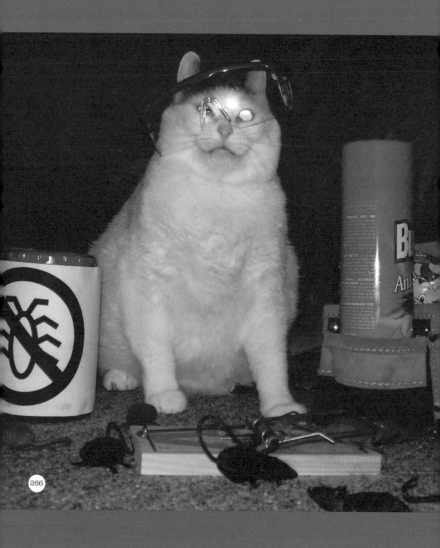

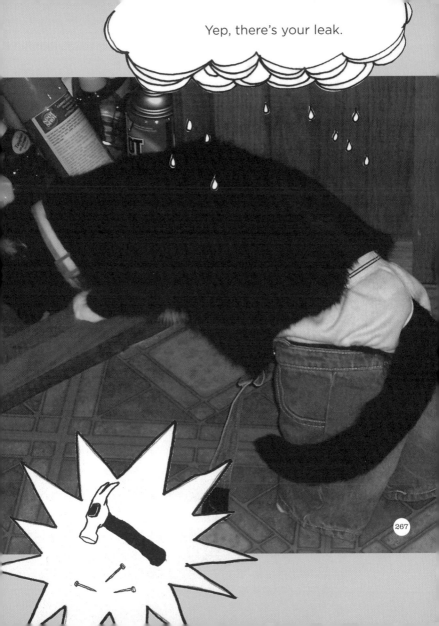

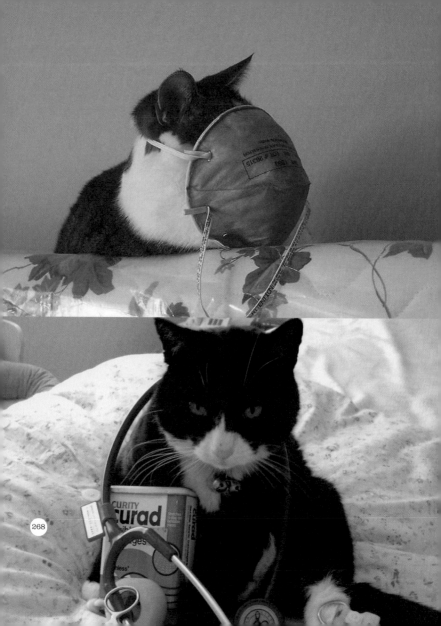

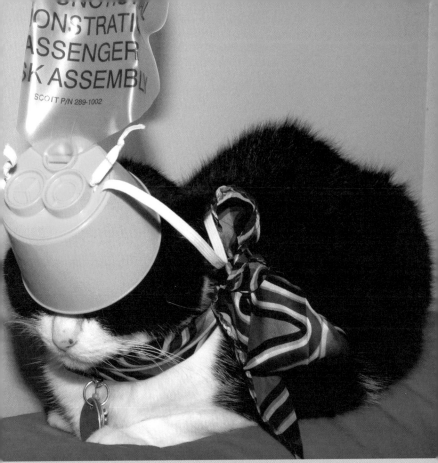

SCOTT P/N 289-1002

ONSTRATI
ASSENGER
SK ASSEMBLY

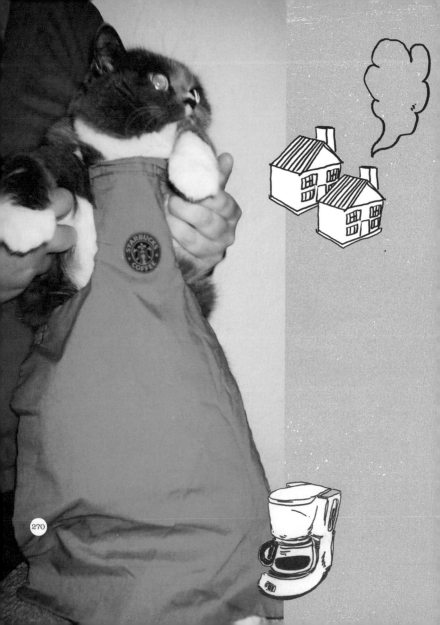

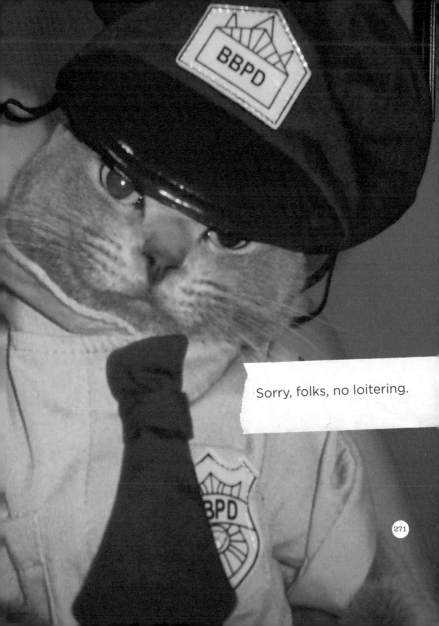

Sorry, folks, no loitering.

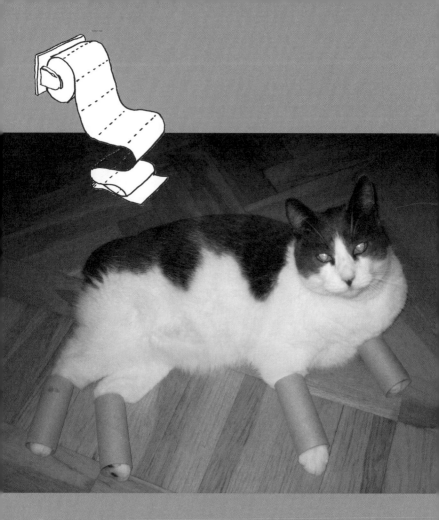

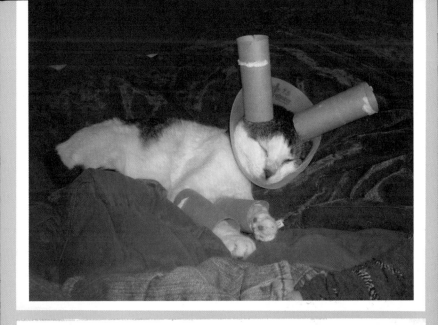

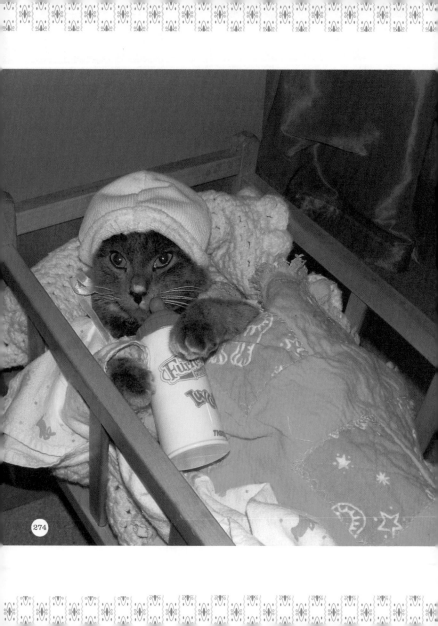

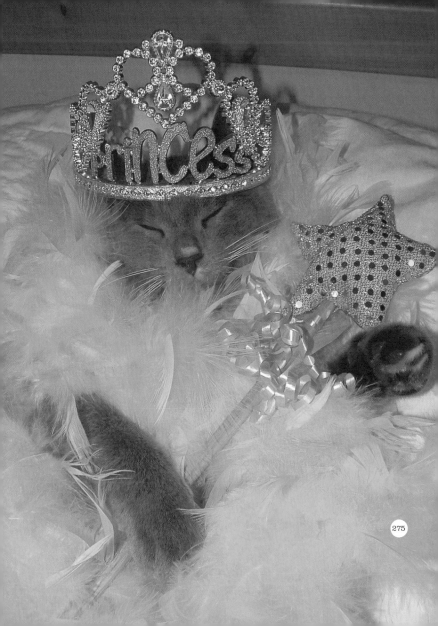

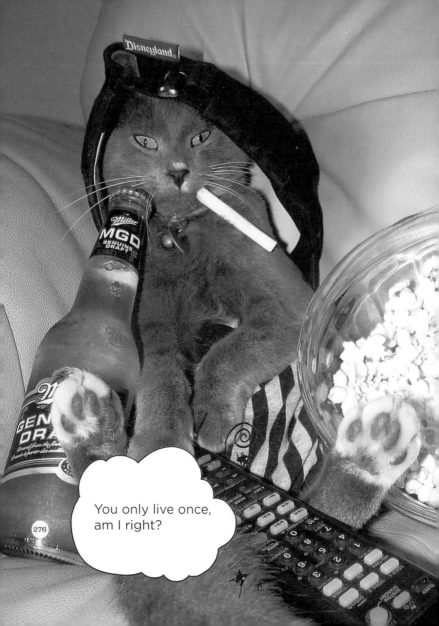

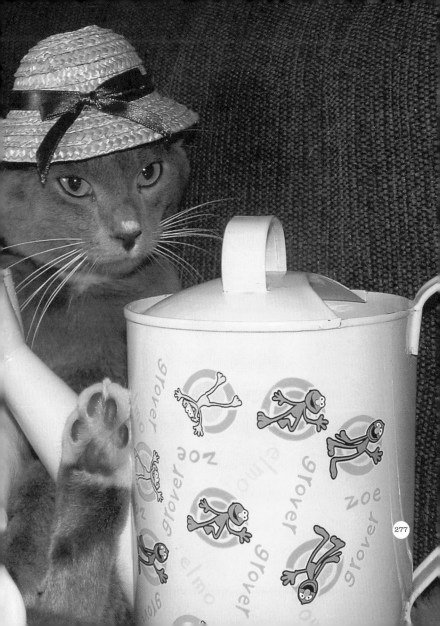

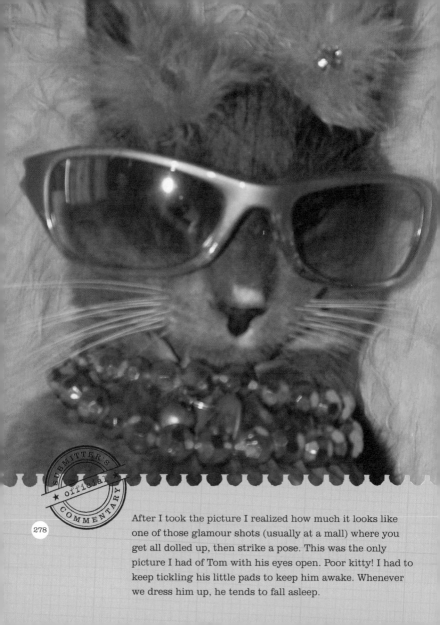

SUBMITTER'S ★ official ★ COMMENTARY

After I took the picture I realized how much it looks like one of those glamour shots (usually at a mall) where you get all dolled up, then strike a pose. This was the only picture I had of Tom with his eyes open. Poor kitty! I had to keep tickling his little pads to keep him awake. Whenever we dress him up, he tends to fall asleep.

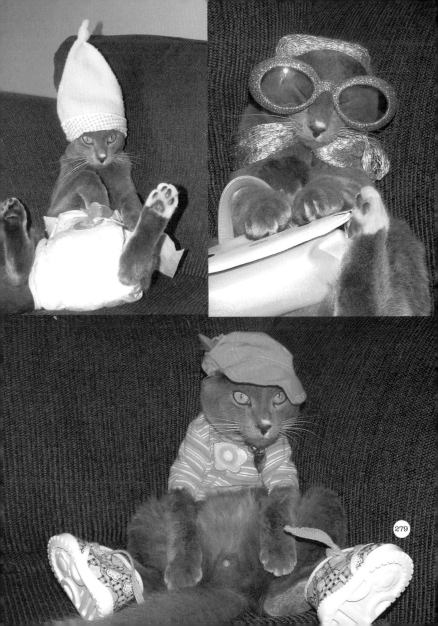

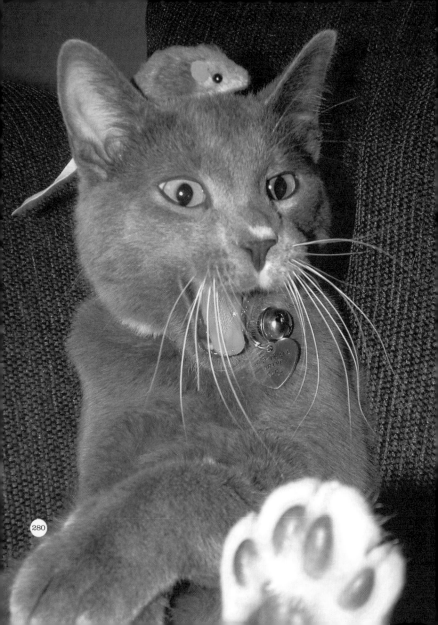

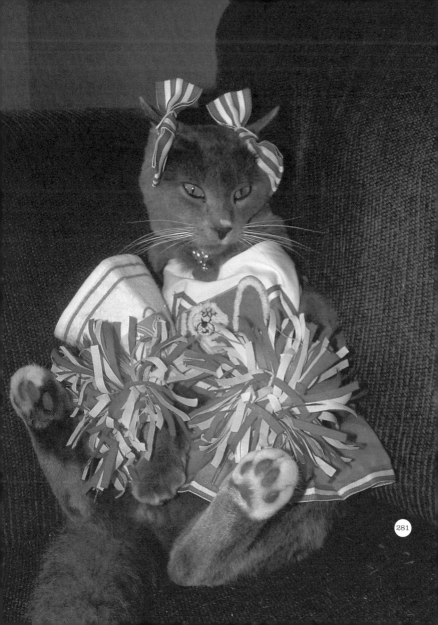

SUBMITTER'S ★ official ★ COMMENTARY

Craig has a hard time making friends with the neighborhood cats, as they are intimidated by his size. One day, Craig was pleasantly surprised to find a mini-zebra trekking through his thick fur. Finally, he had a friend to join him in his favorite activities, which include chasing laser pointers, stealing French fries, and attacking the feet of sleeping humans.

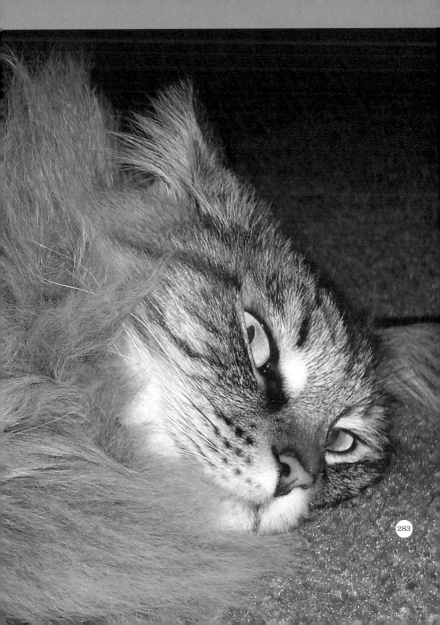
283

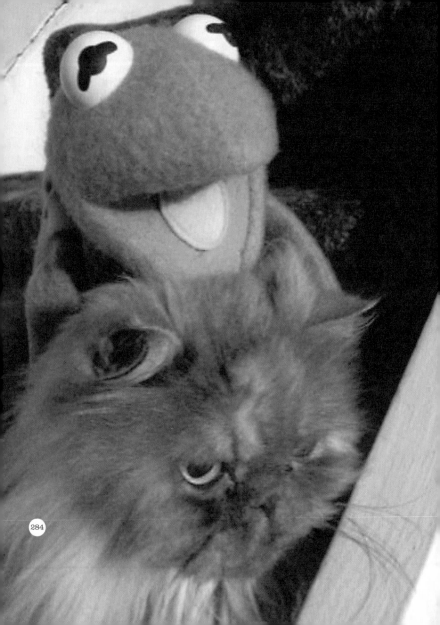

. . . and that's how I make my finger glow.

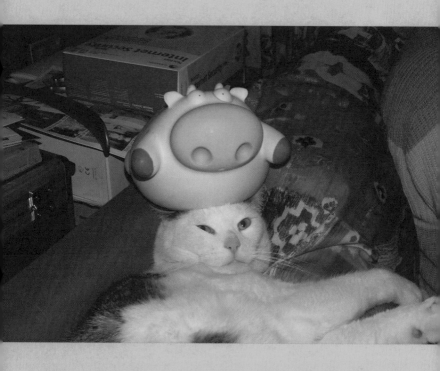

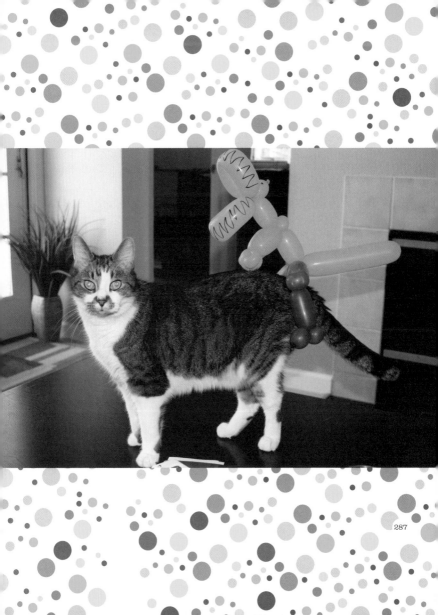

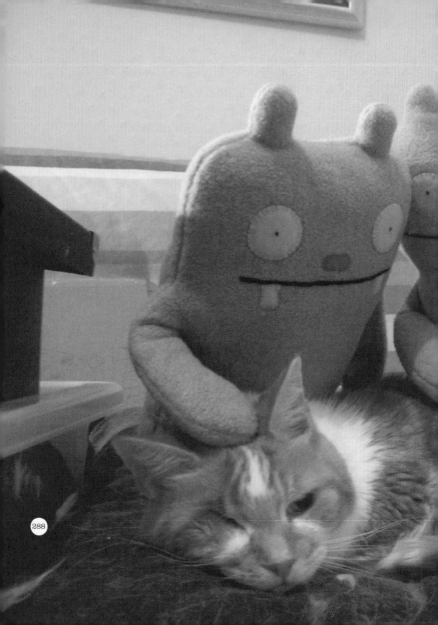

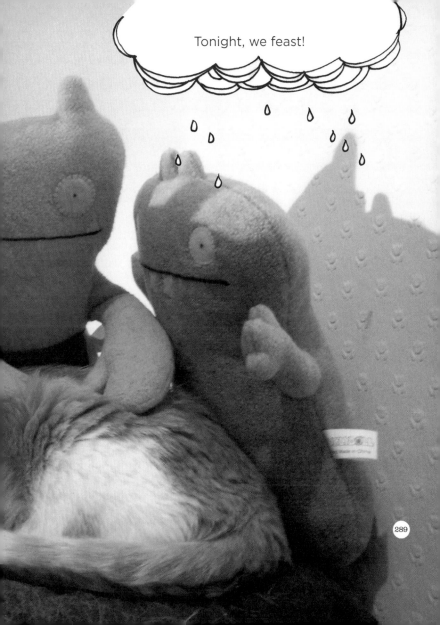

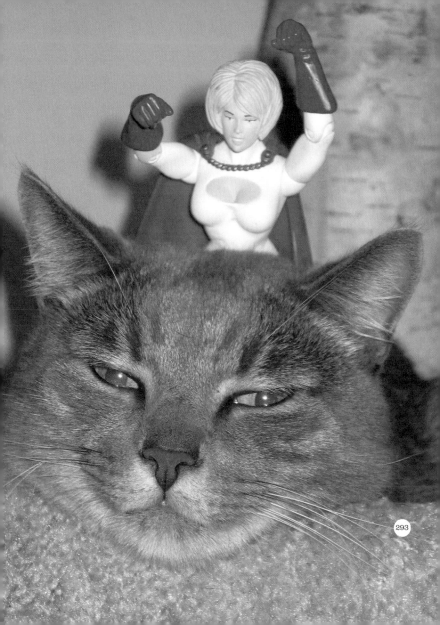

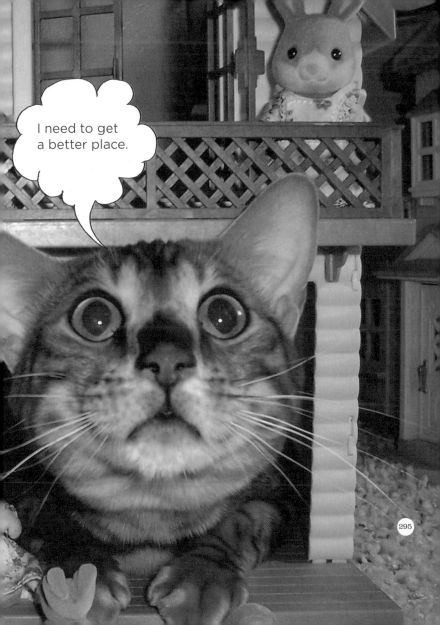

Kitnit is very odd. We can never leave food unguarded because she drags it off the table and eats whole steaks, pork chops, chicken breasts, and hamburgers. If we try to take food from her, she growls at us and eats at the same time.

She eats anything: beans, pancakes, black olives, honeycombs, and even marshmallows! We actually made a list of all the things that she takes from the dinner table.

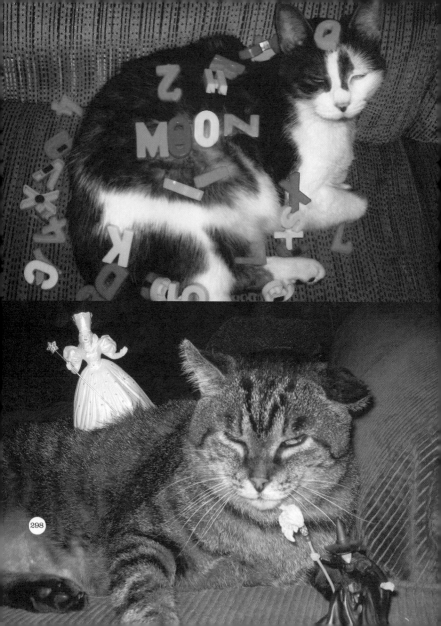

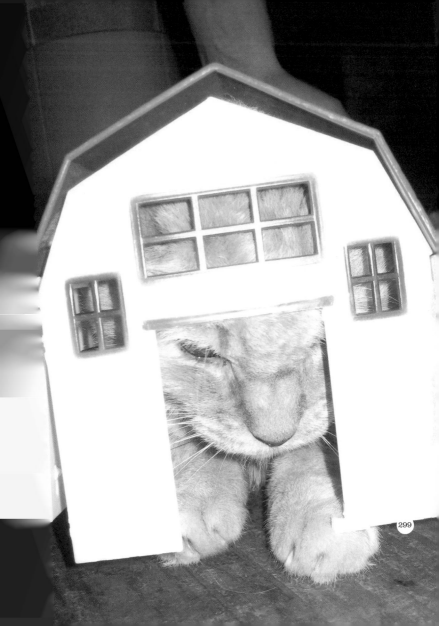

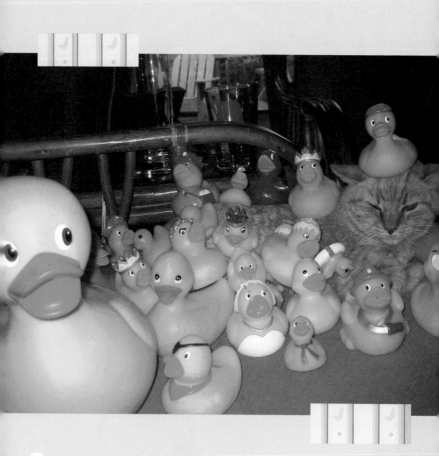

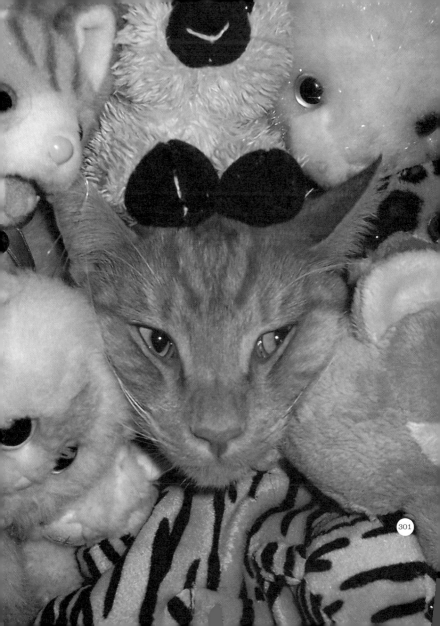

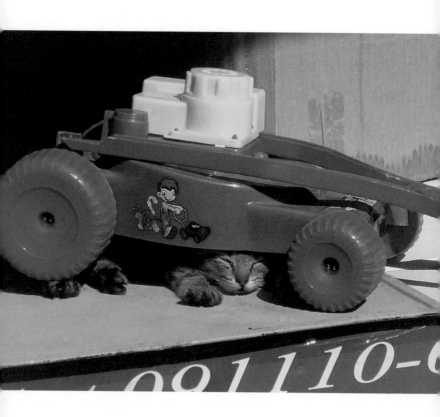

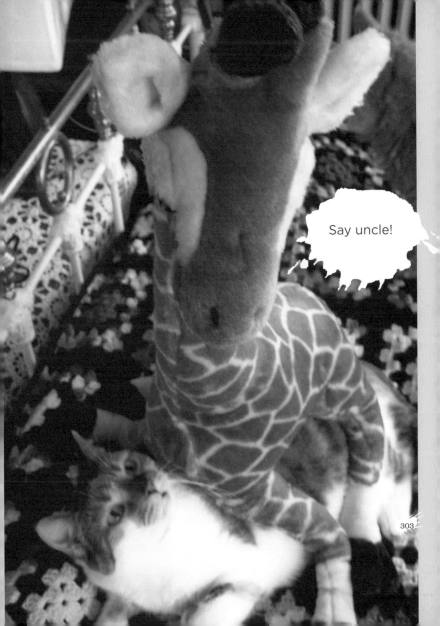

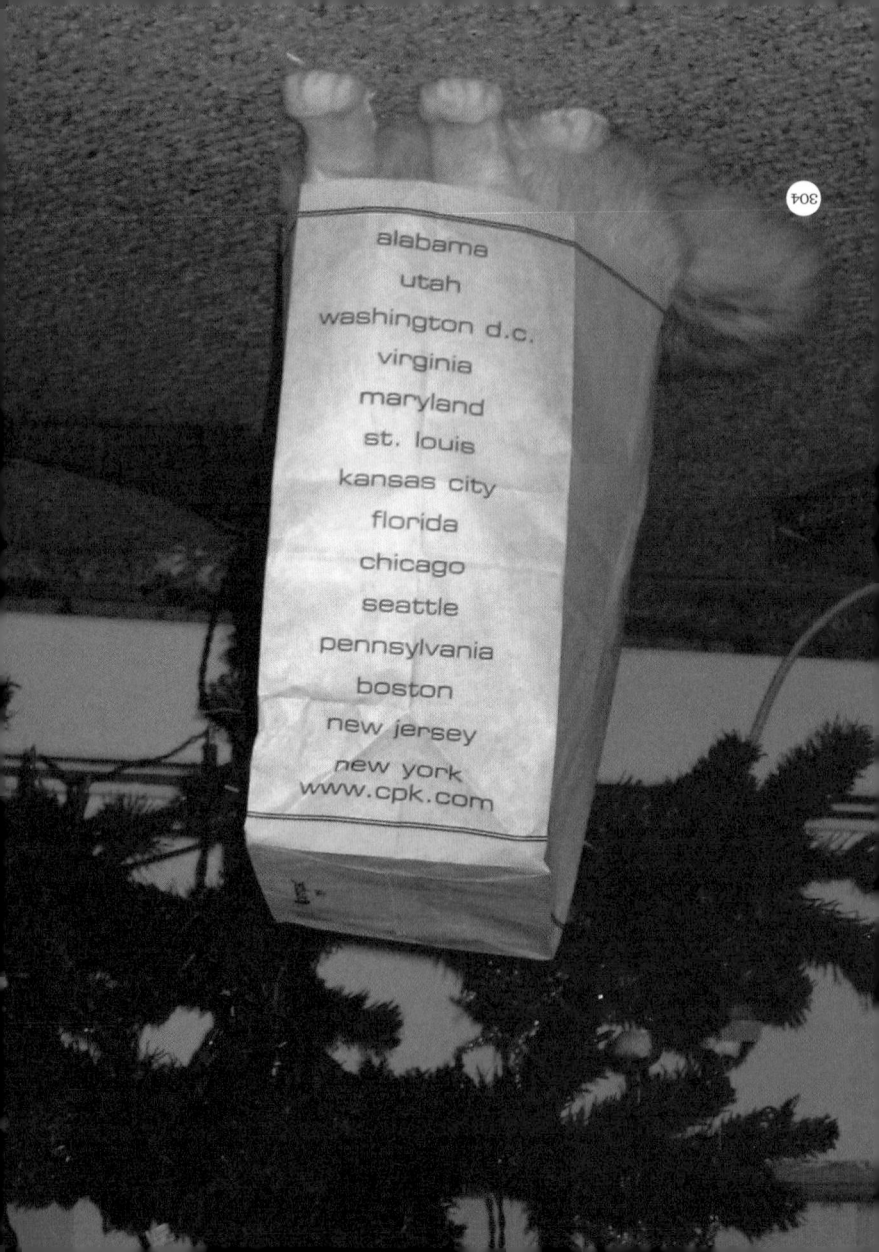

alabama
utah
washington d.c.
virginia
maryland
st. louis
kansas city
florida
chicago
seattle
pennsylvania
boston
new jersey
new york
www.cpk.com

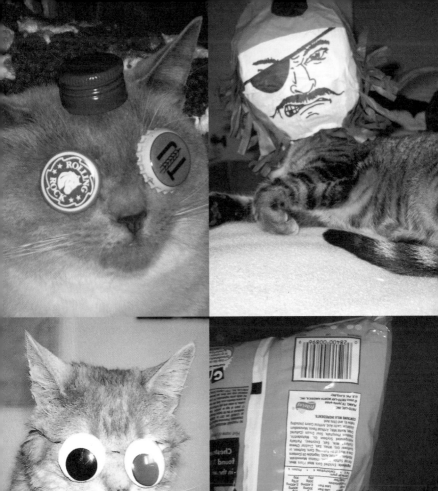

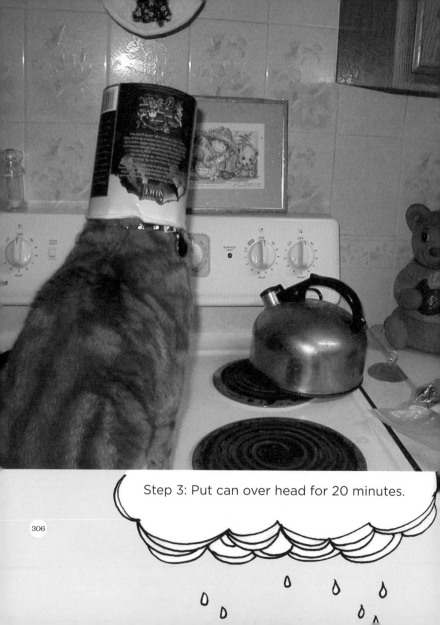

Step 3: Put can over head for 20 minutes.

Since I adopted him, Jordan has always had a fixation with bathrooms. When he was a kitten, he used to flush the toilet just to watch the water swirling around, which resulted in a few panicked 2 A.M. awakenings for me until I figured out that it wasn't a burglar in the apartment using the bathroom, it was the cat. He loves to bat ping-pong balls around in the bathtub, a dripping faucet will fascinate him for hours, and the sound of the toilet paper rolling on the spindle will bring him running from another room. He just digs the bathroom.

When he was about two, I moved and he discovered the vanity drawers in the downstairs powder room . . . and spent hours trying to figure out **Step 1,** how to open a drawer. He accomplished this within a few days. **Step 2** was wedging his eighteen-pound fuzzy butt into the drawer, which he did immediately upon opening the drawer. He then proceeded with **Step 3,** trying to dig his way out of the back of the drawer. Over and over again. With no front claws, he didn't make much progress, but that didn't deter him; day after day, for as long as I lived there, he would shoehorn himself into that drawer and dig. Watching TV at night in the adjacent living room, I could hear the muted sound of his pawpads whisking at the bottom of the drawer. Anytime I couldn't find him, all I had to do was look in the powder room, and there he was, digging. And digging. When I'd close the powder room door, he'd cry for me to open it so he could get to his drawer. He was content to go in there, open the drawer, climb in, and dig.

Three years later, when I moved again, he was still trying to get to the bottom of that drawer, at least two or three times a week.

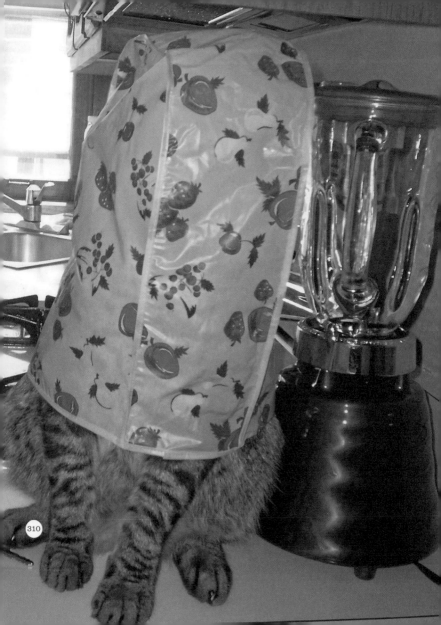

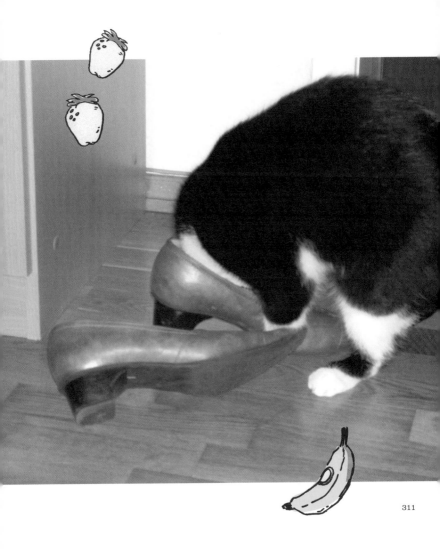

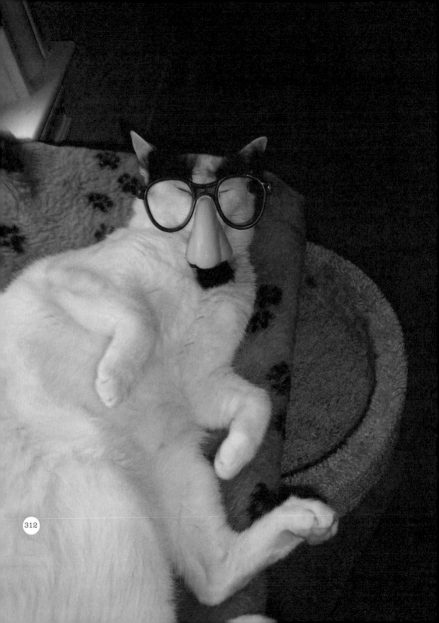

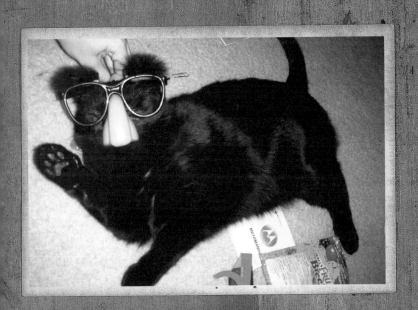

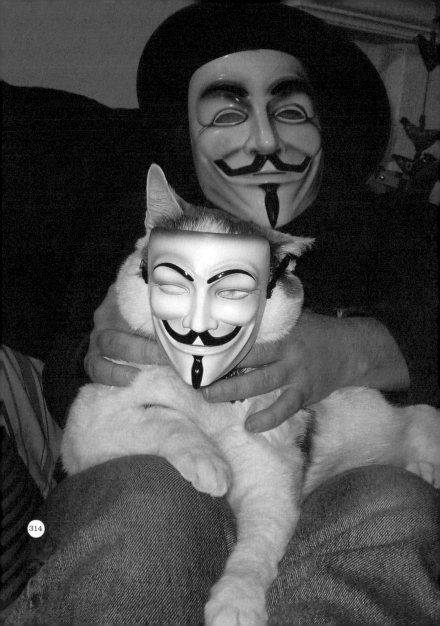

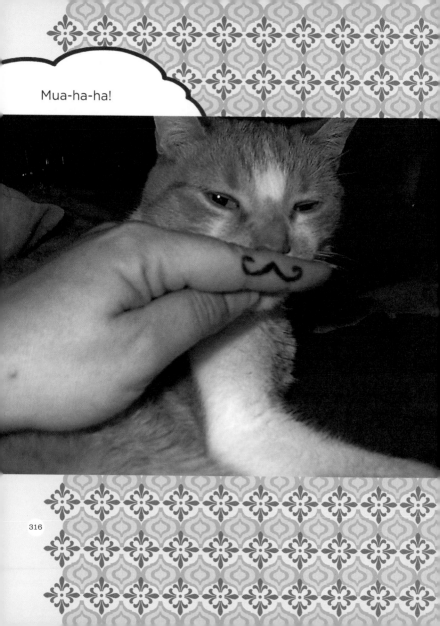

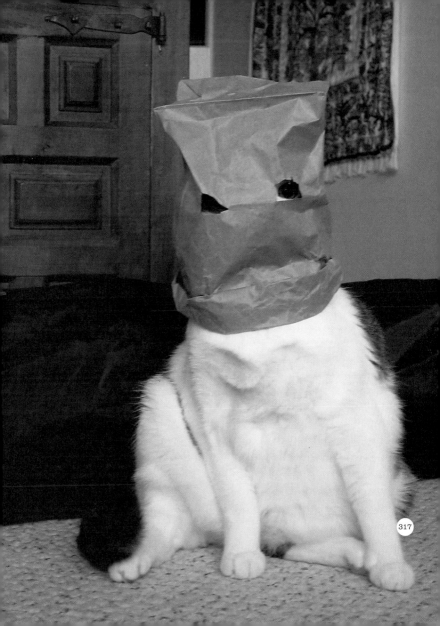

INDEX

ACKNOWLEDGMENTS

This book and the Web site would not have been possible without the help of Belinda, Brent, David, and Jason. Thanks to my friends, family, and all of the wonderful cats that have entertained me for the last two years. Thanks to everyone who contributes to the site and to those I've met along the way. The stuff-on-cat revolution wouldn't be possible without the fantastic community behind it. You're the best!

Mario Garza is a graphic designer, student, and professional blogger. Inspired by the things he could stack on his cat, Love, he launched Stuffonmycat.com in the spring of 2005. Mario spends his days running an independent graphic design and screen-printing studio in Fresno, California.